The Postcard History Series

Sarasota and Bradenton
Florida

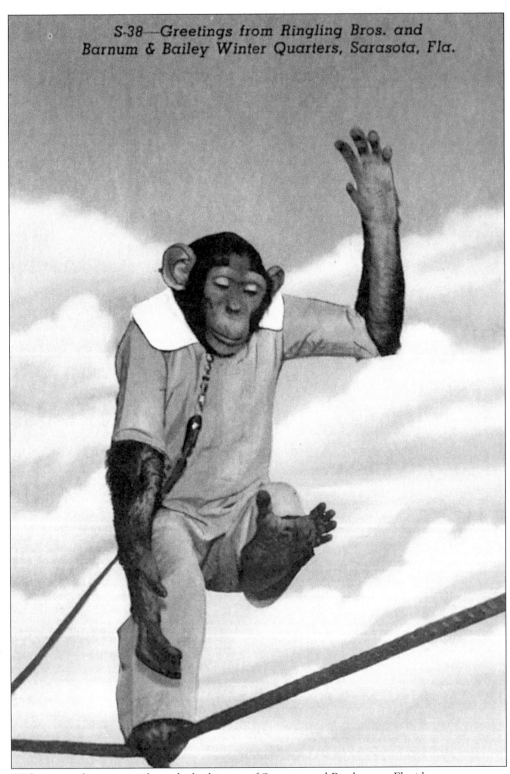

Welcome to this journey through the history of Sarasota and Bradenton, Florida.

THE POSTCARD HISTORY SERIES

Sarasota and Bradenton
FLORIDA

Bonnie Wilpon

Copyright © 1999 by Bonnie Wilpon.
ISBN 0-7385-0053-4

Published by Arcadia Publishing,
an imprint of Tempus Publishing, Inc.
2 Cumberland Street
Charleston, SC 29401

Printed in Great Britain.

Library of Congress Catalog Card Number: 99-61283

For all general information contact Arcadia Publishing at:
Telephone 843-853-2070
Fax 843-853-0044
E-Mail arcadia@charleston.net

For customer service and orders:
Toll-Free 1-888-313-BOOK

Visit us on the internet at http://www.arcadiaimages.com

CONTENTS

Acknowledgments		6
Introduction		7
1.	Changing Streets and Byways	9
2.	Business and Industry	17
3.	Community Life	33
4.	The Tourists Arrive	53
5.	Hotels, Homes, and Restaurants	71
6.	Festivals and Attractions	89
7.	The Circus Stays in Town	105

ACKNOWLEDGMENTS

Many thanks to Wynelle Deese for introducing me to Arcadia Publishing and for her advice and encouragement. I greatly appreciate the time and enthusiasm of Dana Sanborn and of Manasota Mensa's June Brasgalla, Marianne Gill, and Chris Brunner as they shared their knowledge of the area with me. Thanks to Leah Schnall and Bob Kaiser for helping me gather resources. And I am especially grateful to Dana and Sue Sanborn for allowing many of the postcards from their collection to be used in this book.

INTRODUCTION

This history, told more in pictures than in words, highlights the things for which the Sarasota-Bradenton area is best known.

Hernando de Soto, the first Spaniard to come ashore in 1539, and his daughter, Sara, bequeathed a beautiful legend, an annual pageant, and a national memorial. The old Creek story begins with de Soto's men capturing a young Indian prince, Chichi-Okobee. The youth did not try to escape because he had seen Sara, fallen in love with her, and wanted to be near her. When he became ill and attempts to cure him failed, Sara was permitted to care for the dying man, and her ministrations miraculously caused Chichi-Okobee to live! But then Sara fell ill. Chichi-Okobee went to his father's village deep in the Everglades and fetched a medicine man to help, but Sara died. Broken-hearted, Chichi-Okobee begged de Soto to let Sara be buried in Sarasota Bay, the loveliest spot along the shores. Sara was placed in a funeral barge canoe and, accompanied by her faithful Chichi-Okobee and 100 brave warriors, taken to the exact center of the bay and lowered into the water. The warriors, Chichi-Okobee included, then splintered the accompanying canoes and sank beneath the waters of the Gulf of Mexico, forever to guard the resting place of the beautiful Spanish maiden. Some say that Sara de Soto gave Sarasota her name, though many believe the town's name, first Porte Sarasote then Sara Sota, came from the Seminole trading post known as Saraxola. By 1839 though, the official name was Sarasota, and later its motto was "May Sarasota Prosper."

Bradenton was originally named Braidentown, an accidental misspelling of early settler Dr. Joseph Braden's name. In 1905, the letter 'i' was dropped and, in 1924, since the town wanted to become known as a city, "Bradentown" became "Bradenton." Its town motto became "The Friendly City."

Both Sarasota and Bradenton were once in Manatee County, with the town of Manatee designated as its county seat. In 1921, Sarasota and Manatee became separate counties; in 1944, the town of Manatee was absorbed by Bradenton and became known as East Bradenton.

Dr. Joseph Braden (who never did practice medicine in Florida) and Maj. John Gratton Gamble arrived from Virginia with their slaves and agricultural equipment in 1842 and developed the sugar industry. The Gamble Mansion and the ruins of Braden Castle still stand to remind us of those pre-Civil War days. In the 1880s, Scottish colonists arrived. John Hamilton Gillespie introduced golf to Florida and built what may have been the first practice course in the United States with two greens and a long fairway in a natural clearing in the woods on Main Street. Gillespie convinced Florida railroad magnate Henry Plant that golf would be a valuable

tourist attraction and went on to design courses for Plant in other Florida cities.

By the early 1900s, steamers could take the inland waterway from Tampa Bay directly into the wharf at Sarasota. The Gulf Coast Telephone Company had its first subscribers, the Warren Opera House seated 800 people under gas lights, and the first sidewalks appeared downtown. The Seaboard Air Line Railway went from Tampa to Naples, stopping in Manatee and Sarasota for passengers. The first bridge across the Manatee River opened, and major growth had begun. In 1910, Mrs. Potter Palmer, a society woman known for her business acumen, visited and fell in love with the bay area. She bought 213 acres and a house to serve as her winter home. Eventually, she owned over 80,000 acres and established a model cattle ranch and an experimental farm. Her influence established the area as a stylish winter resort.

To welcome visitors, including the Tin Can Tourists, hotels, motels, and attractions sprung up. Cattle were banished from the city streets, seawalls were built, and the area's image changed from a fishing village to a progressive city. Tourists brought money and growth, real estate boomed, and businesses flourished. In addition to the cattle and citrus industries, the marketing of truck crops such as celery and tomatoes developed. In 1925, the first Mennonite family came to Sarasota to work on the celery farms. Over the years others joined them, and a sizeable Mennonite colony was established. Many of the Plain People still dress in somber garments, and the area has many wonderful Amish-style restaurants.

In the mid-1920s, big league baseball became a permanent part of both Sarasota and Bradenton when the New York Giants made the area their spring training headquarters. Indianapolis did the same in 1929–1930. The Boston Red Sox made Sarasota their training headquarters in 1933. The Chicago White Sox stage exhibition games today in Sarasota, and the Pittsburgh Pirates make Bradenton their spring training site.

John Ringling's love affair with the area began when he moved the winter quarters of the Ringling Brothers, Barnum and Bailey Circus, The Greatest Show on Earth, to Sarasota in 1927. The Baraboo, Wisconsin native moved his home there as well. The contributions of this well-known family included extensive real estate development, the John and Mable Ringling Museum of Art, and the Ringling Estates, now home to the Asolo Center for the Performing Arts and the Circus Museum.

During the 1930s and 1940s, the Work Projects Administration (WPA) enabled the development of Myakka State Park, Bayfront Park, the Sarasota Municipal Auditorium, and the Lido Beach Casino. The 1950s and 1960s brought intensive beachfront development along the Gulf of Mexico and a proliferation of modern conveniences and large condominiums.

Today the Sarasota-Bradenton area, including its offshore islands of Lido, Longboat, St. Armand, and Siesta Keys, as well as Anna Maria Island, is known as a beach resort, art community, and tourist spot. Along the kinder, gentler Gulf of Mexico coastline, the beautiful scenery, warm weather, and friendly people attract permanent residents as well as visitors.

I hope you enjoy this pictorial historical tour as much as I delighted in compiling it.

One
CHANGING STREETS AND BYWAYS

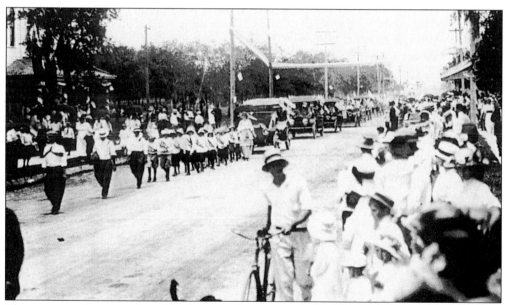

The opening of good roads and bridges was always a cause for celebration during the early years in Manatee County. The Victory Bridge, named in honor of World War I, officially opened on August 19, 1919. Although voters had approved a construction plan in 1916, numerous delays meant that construction of this wooden bridge would take three years. This free bridge replaced the Davis Toll Bridge across the Big Manatee River, connecting Palmetto and Bradenton. Victory Bridge enabled people and vehicles to take a direct route to Manatee, rather than traveling east to cross the river via the old Davis Bridge.

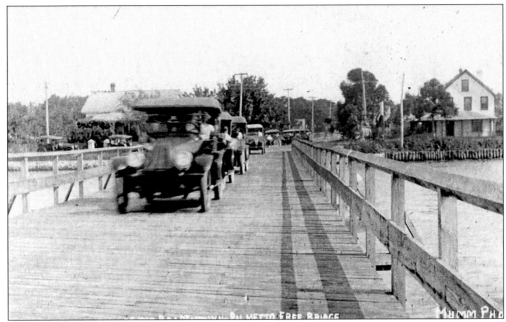

A parade from Palmetto led the inauguration ceremony, crossing Victory Bridge to Bradenton. The procession was led by County Commissioner Pope Harllee, who drove a new Model T Ford from the Harllee and Harrison Ford Agency. At the draw, an official ribbon-cutting ceremony was held. Then the parade-goers adjourned to the Bradenton City Park to listen to speeches and enjoy an afternoon picnic.

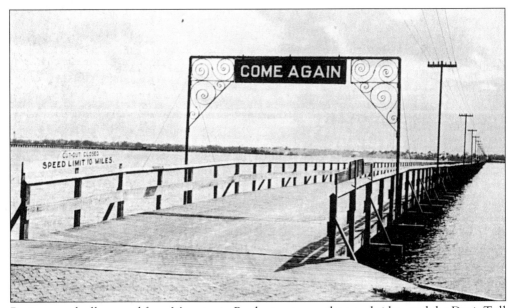

Business gradually moved from Manatee to Bradenton to use the new bridge, and the Davis Toll Bridge was closed. As the number of cars in the area increased, the wooden bridge became obsolete. In 1927, Victory Bridge was replaced by the E.P. Green Bridge, named for the Bradenton businessman who spearheaded its development. He would be proud to know that, in 1986, his bridge became a modern, four-lane span.

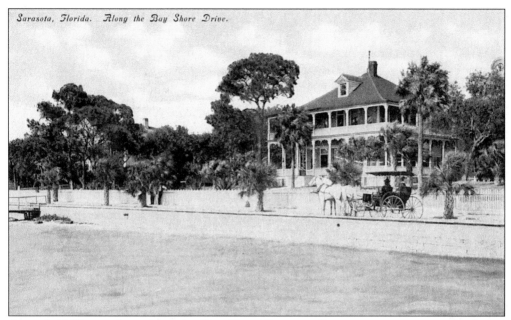

Around 1905, traveling along the Bay Shore Drive in Sarasota was a quiet and relaxing experience. Whether on foot or in a horse-drawn carriage, the balmy breezes and soft lapping of the Gulf of Mexico were to be enjoyed. No traffic jams here!

In 1911, when this postcard was mailed from Bradenton, the Peninsular Telephone Company had over 230 subscribers. The local newspaper offered a "20 acre tract, 1 1/2 miles north of town. Fine orange land, 2 acres cleared. New 5-room house. Price, $600." G.P.'s postcard message read, "This is the street we are on . . . the house is just beyond the bridge . . . from the bridge we can look out on the river just a little way from the creek."

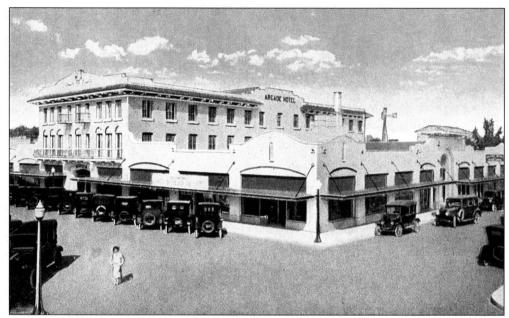

The Arcade Hotel was on the north side of Manatee Avenue between Ninth and Tenth Streets West. There was a large fishpond and fountain under a skylight in the center of the building. The hotel stairway was open all the way from the first floor to the top, so you could stand on the top floor and look down into the pool. Built in 1923, the hotel was demolished in 1960, and the entire building was razed in 1978.

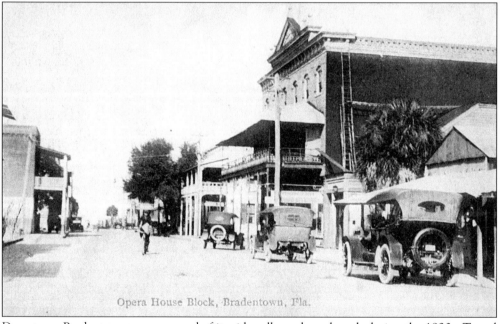

Downtown Bradenton was very proud of its sidewalks and good roads during the 1920s. Travel by automobile became more common, and cars lining the streets spoke of boom times for the area.

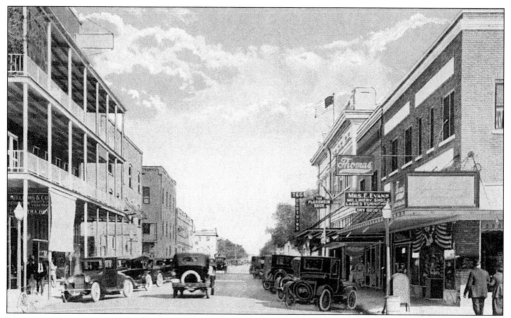

Manatee Avenue was the heart of the shopping district. To the right, you can see Mrs. E. Evans Millinery, Shoes, Ladies' Furnishings, and Dry Goods. Farther down the street are the Florsheim Shoe and T & G Clothing. The mailbox on the corner saved busy shoppers the trouble of a trip to the post office.

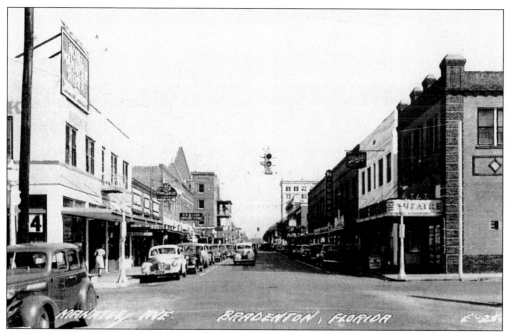

A decade later saw a traffic light installed . . . and different shops along Manatee Avenue. The State Theatre graced the corner, with Schlitz as its next-door neighbor and McCrory's Five and Dime down the street. Across the road was the B & B Cash Grocery, a G.E. Appliance store, and the Buick Building, with a sign pointing to the Hotel Manatee River.

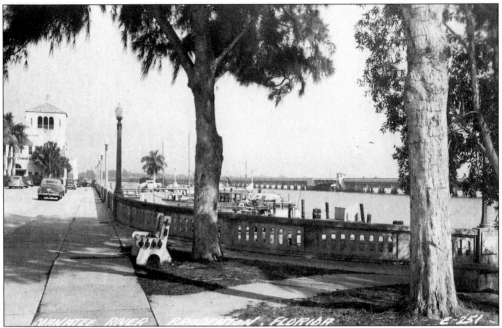

Everyone approaching Bradenton from the north was greeted by the pier, which juts out into the Manatee River. Completed in 1927, it was dedicated to the memory of Manateeans who gave their lives in WW I. The pier housed a radio station and served as an entertainment center at one time.

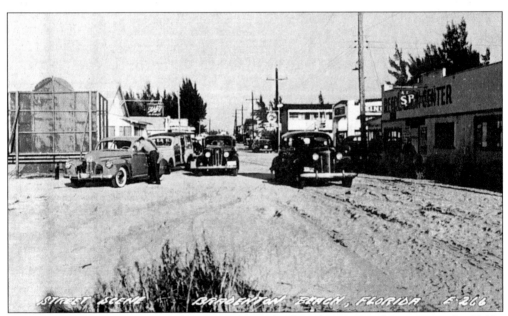

The sand still made driving a challenge on the roads of Bradenton Beach, even into the 1940s. The Island Market is on the left side of the street, while the Sinclair Station and the Recreation Center can be seen on the right.

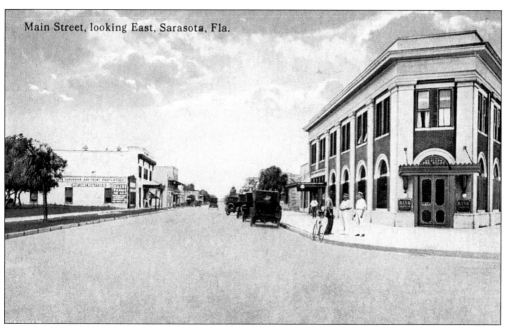

Main Street, Sarasota, looking east, is seen here as it appeared around 1912. A green awning sheltered the entrance to the Bank of Sarasota, which had a dentist's office upstairs. Across the road was the office of the West Coast Realty Company, offering "suburban bay front properties" and "10-acre farms for sale."

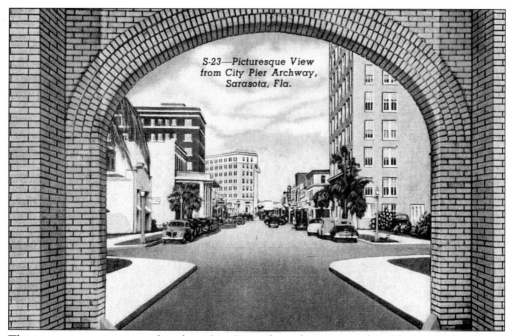

This picturesque view was taken from City Pier, where the Municipal Building and Chamber of Commerce were located. The arch was actually built over the city dock; if you were the photographer, you would be standing directly under city hall.

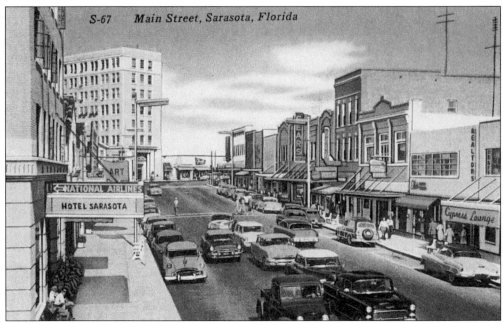

Sarasota's Main Street was bustling during the 1940s. This view shows the Hotel Sarasota to the left, and the Cypress Lounge as well as the Sears Store on the right. Benches placed along the sidewalks provided spots to rest and chat with friends.

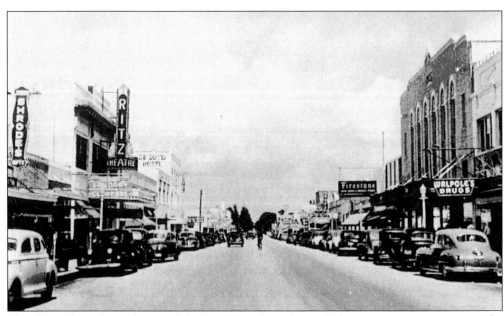

Shrode's sold jewelry and gifts, while City White Laundry and Cleaners was at your service. The Ritz Theatre provided entertainment, and you could have a meal at the De Soto Hotel. The right side of the street boasted Walpole's Drugs as well as Firestone Auto Supply and Service.

Two
BUSINESS AND INDUSTRY

There is a Difference in Celery!

Celery from some sections of the country is crisper and tastier than that from others. Bradenton (Manatee County) celery is exceptionally good because it is (1) grown by advanced methods, (2) washed thoroughly and pre-cooled before shipment, (3) kept fresh in refrigerator cars and (4) transported a shorter distance to the North.

BRADENTON (Manatee County) CELERY IS HEALTHFUL

● It provides Vitamin B
—Calcium
—Phosphorous
—Iron
—Potash

And adds needed roughage to the diet in a form that is pleasant to young and old.

Make Sure You Get **BRADENTON** *(Manatee County)* **CELERY**

In the 1920s, the area's main vegetable crops were celery, tomatoes, beans, Irish potatoes, sweet potatoes, peppers, eggplant, cabbage, peas, cucumber, and spinach. Many types of fruit were grown as well, including oranges, grapefruits, lemons, limes, strawberries, and watermelon. But the biggest cash crop was celery, and long before the "Burger Wars," the "Celery Wars" created fierce competition among growers. In the 1930s, Manatee County boasted that its celery "is grown clean. In place of the dirt used in some states, boards or strips of paper are placed against the stalks to bleach them."

You'll ENJOY SARASOTA CELERY *more!*

There *is* a difference in celery! Sarasota celery is grown for flavor, for tenderness. Right after cutting it is thoroughly washed and cooled. It is shipped in refrigerator cars. It reaches northern markets in better condition because it gets there faster than celery from other parts of the country.

And Sarasota Celery Provides:

- Vitamin B—said to tone intestines.
 Calcium and phosphorous—help build sound bones and teeth.
 Iron—helps make blood healthy.
 Potash—likely to overcome acidity.
 Roughage—pleasant to take in celery.

For Most Enjoyable Celery... Look for **SARASOTA CELERY**

Not to be outdone, Sarasota claimed "firm, crisp and tender" celery. In years past, cattlemen had built their ranches and beef stock by the open range method, and unfenced grazing was the rule. For many years most of their cattle was shipped to Cuba for sale. The ranchers and the farmers fought many bitter battles until, finally, open ranging was outlawed. Crops could then be planted, harvested, and packed for truck shipment to the North.

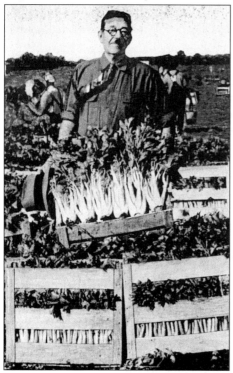

Palmer Farms was among the very first to begin the celery industry in 1927. Celery was grown by a variety of farmers and marketed by the Palmer Farms Growers Association, a cooperative.

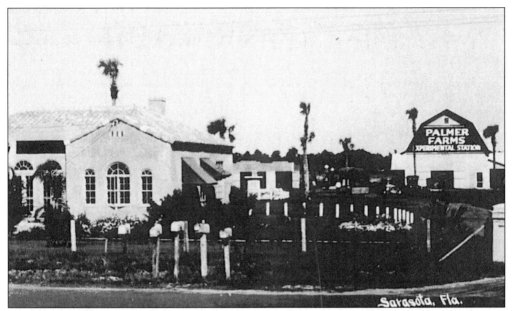

Located between what is now I-75 and Cattleman Road in Sarasota, Palmer Farms operated an Experimental Station. This enterprise was begun by Mrs. Potter Palmer, a society lady and entrepreneur, after she made her home in Sarasota.

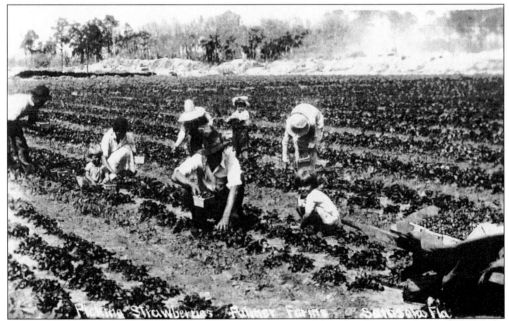

Palmer Farms used the newest scientific methods to improve crops that could be grown in the native Florida soil. Even small children were put to work at strawberry harvest time. In later years, many Palmer Farms acres were sold to the City of Sarasota. The city dredged out much of the land to make lakes to handle flooding due to drainage problems.

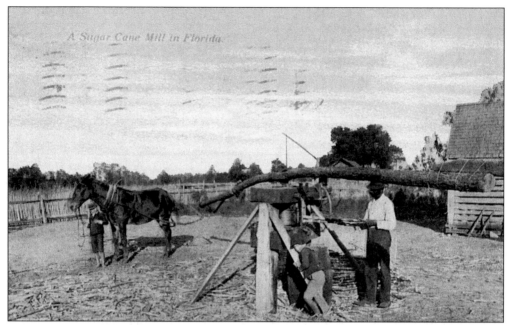

Sugar cane has always been an important crop in Manatee. It was to develop the sugar industry that Dr. Joseph Braden and Maj. John Gratton Gamble came to settle the Sarasota-Bradenton area. This postcard, mailed in 1912, shows cane being fed into a crude mill to extract the juice from which sugar would be made.

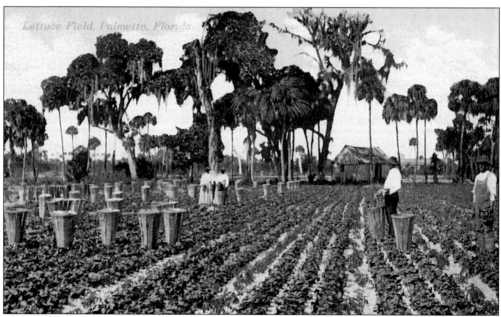

The Manatee County Growers' Association was formed in 1918 and had a membership of about 200 farmers. As members of a large group, the growers could develop better marketing and financing. The association built and operated packing houses in Bradenton, Palmetto, and other Manatee county towns. This lettuce field's owner could well have been a member of the association.

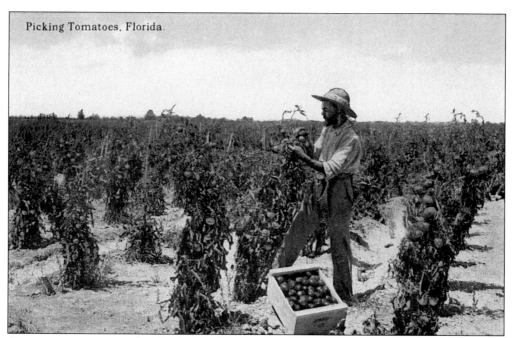

Over time, tomatoes replaced celery as the biggest vegetable crop in the area.

Tin's famous Chinese vegetable farm, on U.S. 41 in South Bradenton, shows a busy harvest in progress. The bok toy, a Chinese vegetable, grown here in the 1960s was shipped to Oriental restaurants and suppliers in the northern and western United States.

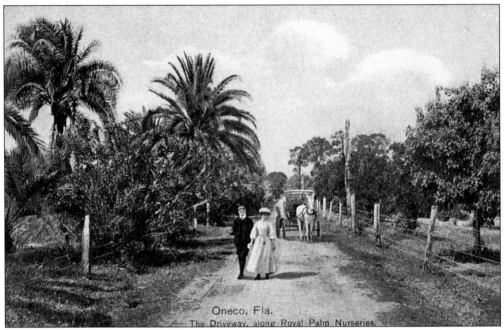

Oneco (pronounced Oh-nee'-koh) got its name because there was only one company (one-co) in town. This was Royal Palm Nurseries, which grew and marketed a variety of plant products.

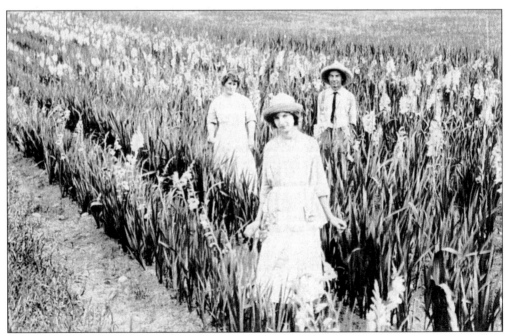

One of the primary flower crops in Sarasota and Bradenton was the gladiola, a tropical plant also known as the sword lily. Gladiolas have sword-shaped leaves and showy, brightly colored flowers arranged in one-sided spikes.

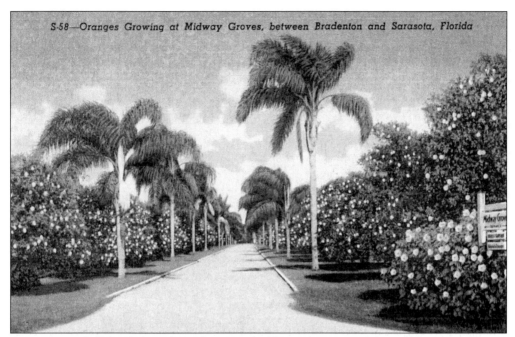

S-58—Oranges Growing at Midway Groves, between Bradenton and Sarasota, Florida

Citrus fruit of all kinds has always been profitable in the area. Midway Groves was located between Bradenton and Sarasota across from the current airport. Its entrance was lined with orange and palm trees. Local residents have fond memories of taking school trips to Midway, where they learned secrets such as turning an orange upside down and twisting quickly to remove its top easily.

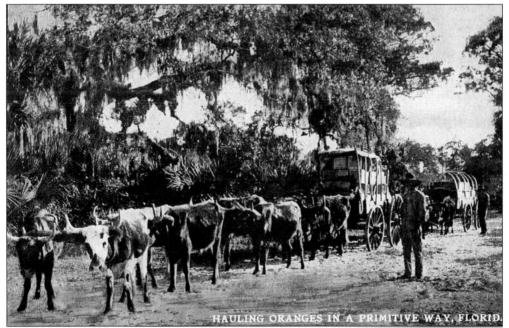

HAULING ORANGES IN A PRIMITIVE WAY, FLORID.

This view from the very early 1900s shows how oranges were transported from the groves to the packing houses. In those days, the fruit was picked by hand, with entire families scaling wooden ladders to reach every bit of hidden fruit.

At one time, the Atwood Grapefruit Company was home to the largest grapefruit grove in the world. In 1897, a mile east of Palmetto on the Manatee River, 500 men helped Kimball Atwood plant 96 miles of grapefruit trees. Pink grapefruit was discovered by a field foreman and has been popular ever since. The company prided itself on "tree-ripened grapefruit which is never artificially colored." The grove stayed in the Kimball family until 1968; today, a large manufacturing corporation stands where the grapefruits once bloomed.

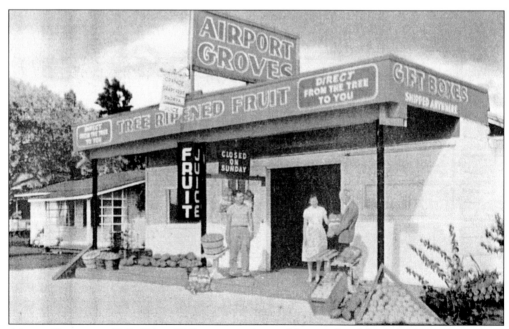

Airport Groves, on U.S. 301 in Tallevast, is a beautiful example of the colorful roadside shops that offered juice and fresh-picked fruit to visitors. As in most fruit stands, employees encouraged visitors to bring their cameras and tour the groves.

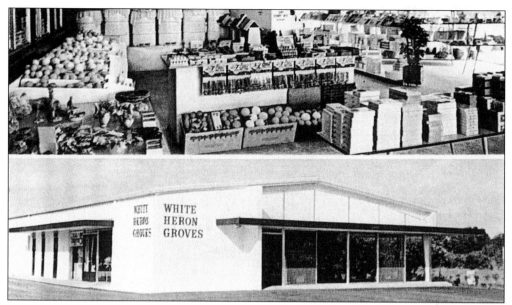

A peek inside the White Heron Groves shop would reveal citrus, honey, and marmalade for sale.

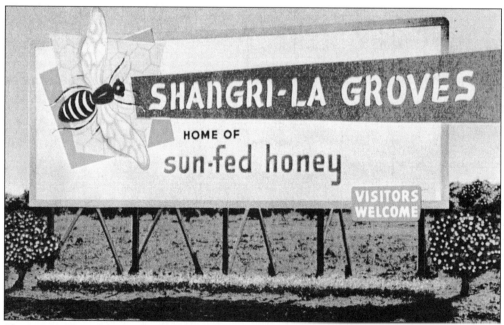

Shangri-La Groves was especially proud of its "world-renowned sun-fed honey." The groves, which offered citrus products too, were located on Route 782, 3 miles south of Sarasota near the drive-in theater.

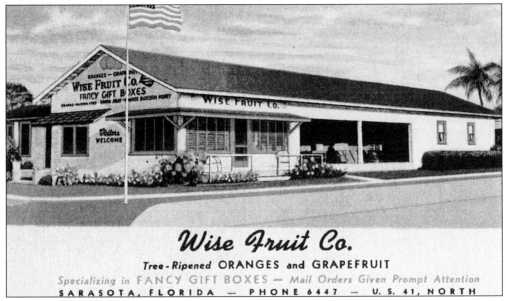

Sarasota's Wise Fruit Company specialized in gift packaging of its locally grown grapefruit and oranges. Note the four-digit telephone number on this early 1940s postcard.

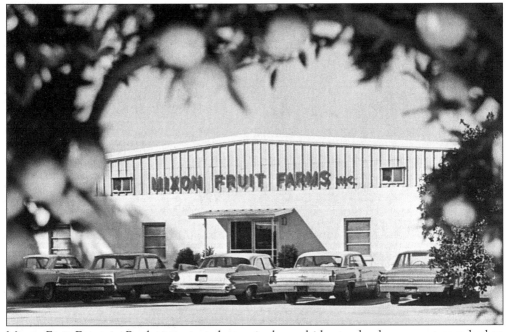

Mixon Fruit Farms in Bradenton started as a single roadside stand, where a customer had to bang on a pan for service, and it grew to be one of Florida's greatest citrus businesses. William P. Mixon and his family weren't afraid of the hard work needed to make their dream come true. By the mid-1970s, there were over 250 acres of groves with 25,000 trees producing over 175,000 bushels of citrus products.

Long before the first European settlers arrived, alligators roamed the Florida waterways. This 1921 real-photo postcard shows a proud Mr. Murphy and his dog after a successful alligator catch. Gator meat and skins were highly prized.

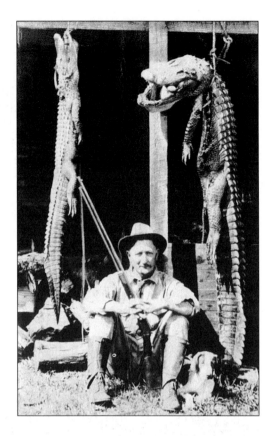

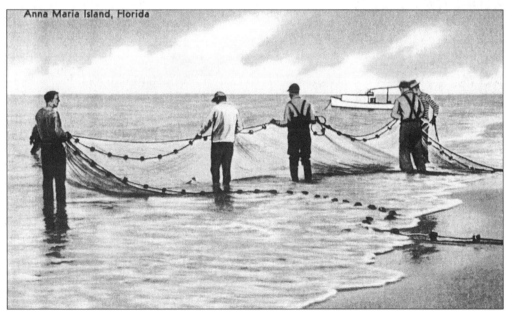

For many years the Sarasota-Bradenton area was known as a fishing village. Before the 1921 hurricane, fish warehouses stood all along Sarasota's municipal pier and railroad dock. These early-morning fishermen are shown hauling in a catch of mullet.

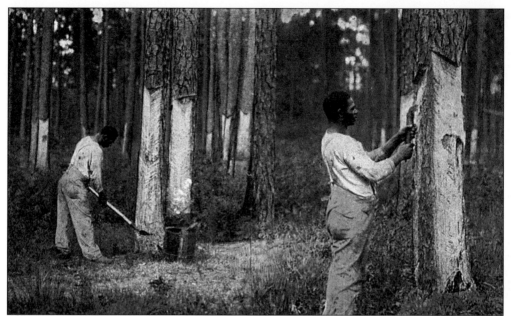

Florida's turpentine trade all but disappeared when the state's pine trees were scraped and not replaced. In 1937, Berryman Longino brought the industry back to life. By 1942, 15,000 mostly African-American workers in the "naval-stores industry" (turpentine, logs, and milled lumber) represented the second-largest occupational group in Florida.

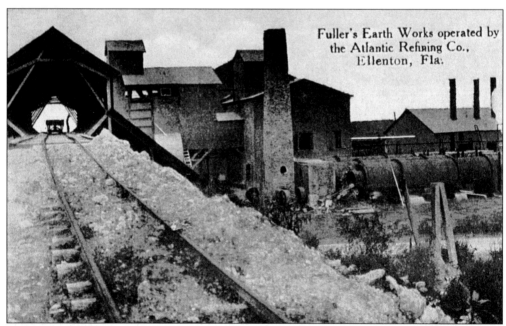

Fuller's Earth is a rare clay that was dug and processed in Ellenton by the Atlantic Refining Company. The clay was first used to clean grease from the clothes of textile workers known as fullers, and that is how it got its name. In refining oils, the Earth removes dark impurities left by clay particles. It's also used as a filler for insecticides, as well as being a key ingredient of the porcelain Kraack pottery.

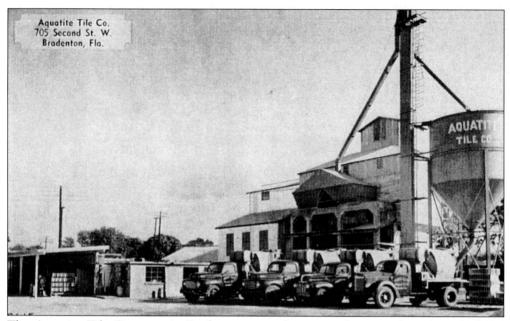

The Aquatite Tile Company in Bradenton was a large manufacturer of concrete products. Among its merchandise was decorative Aqua Slump Brick and marbleized tile in various sizes.

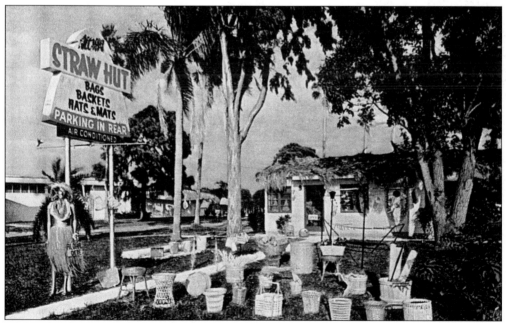

Every Florida coastal town must have its straw/basket shop. Sarasota's Aloha Straw Hut specialized in baskets and bags, placemats and hats.

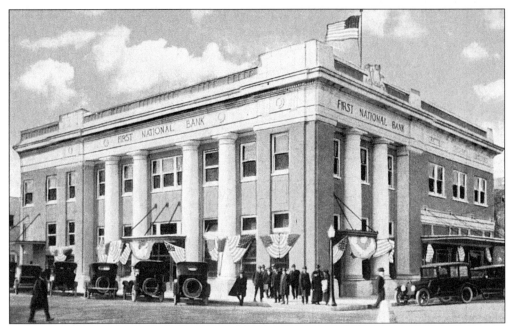

The First National Bank of Bradenton is older than the town itself having gotten its charter in 1899. It was founded as the Bank of Manatee in Braidentown and opened its doors on January 1, 1900. This 1920s view shows its patriotic decorations.

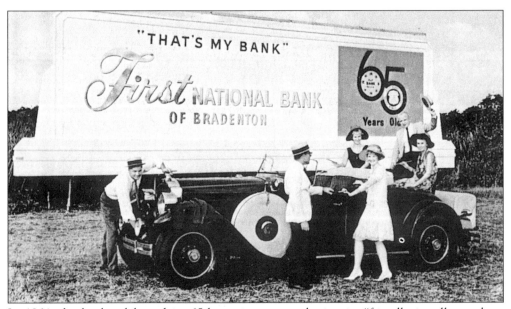

In 1964, the bank celebrated its 65th anniversary, gathering its "friendly installment loan department" around a 1929 Packard. The postcard's message invites customers to see local dealers for a newer model, and "then arrange easy, convenient terms" with its lending team. In 1974, the bank became Ellis First National Bank of Bradenton.

Sharing a building with the Central Hotel, the Manatee Drug Company offered patent medicines, ice cream, sodas, and sundries. The business had been purchased by Dr. John Pelot in 1894, and it was run by father and son. In 1925, the business's name changed to Pelot's Pharmacy, and it remained a family business throughout four generations.

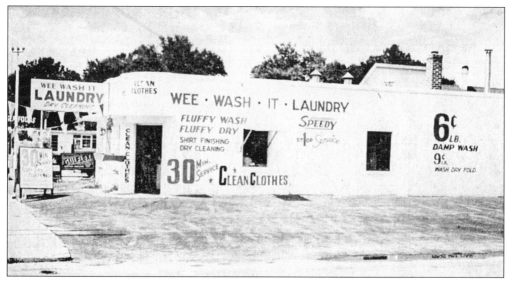

This early view of Paul & Ann's Wee-Wash-It Laundry shows that every inch of a building can be an advertisement. Thirty-minute service for clean clothes was only 6¢ per pound for a damp wash, or 9¢ per pound for a wash, dry, and fold.

Montgomery-Roberts Department Store advertised the Nelly Don line of travel fashions in the early 1940s. "We'll dress you to a fair-you-well and send you on your way," the postcard proclaims. The travel sheer rayon dress on the left sold for $7.95, and the feather faille rayon on the right cost $10.95 in your choice of navy, green, or black.

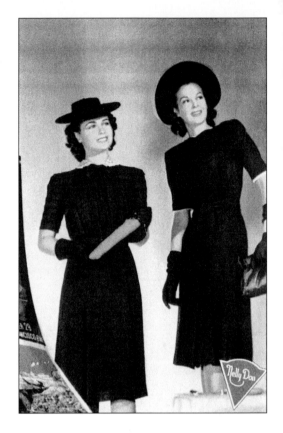

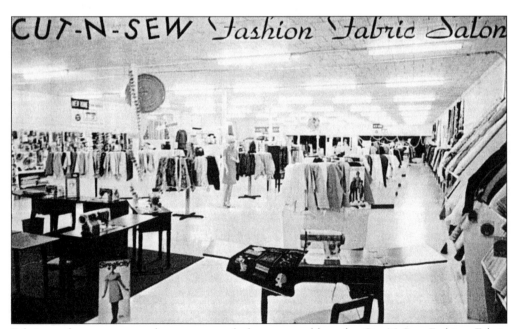

Fabrics and patterns to make your own clothes were sold at the Cut-N-Sew Fashion Fabric Salon in downtown Bradenton in the 1960s. "Come meet the friendly folks" was its slogan.

Three
COMMUNITY LIFE

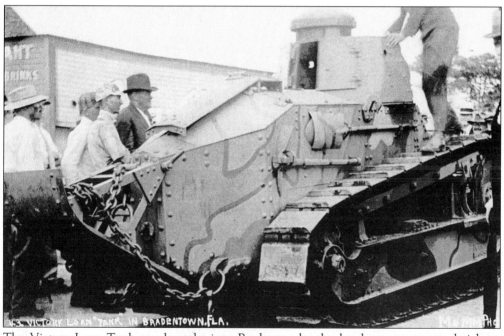

The Victory Loan Tank was brought into Bradenton by the local government to heighten residents' patriotism during WW I. The town began a bond drive to raise funds for the war effort, and the tank helped raise money. In 1916, Sarasota earned the distinction of being the first small city in the United States to enlist an entire deck division of state militia in WW I. The men became part of the Third Division, First Battalion, Florida Naval Militia. At home during the war years, sewer and water mains were brought into all populated areas, and the first asphalt paving was laid. The Siesta Bridge opened, providing the first connection of the keys to the mainland.

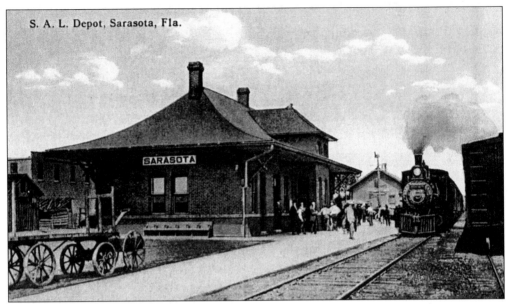

In 1902, the Seaboard Air Line Railway reached Manatee, carrying passengers from Tampa to Naples. Soon, the railroad began to replace ships as a primary means of both trade and travel. In 1927, the first escorted rail trip from Bradenton carried a local group to see the sights in the western states.

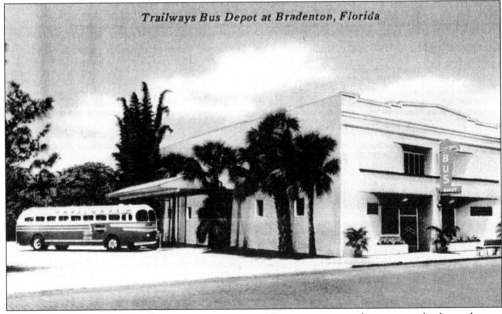

In 1921, the Reo Bus Line began running open 15-passenger speed wagons, which made two trips daily from Sarasota to Tampa. By the 1930s, buses had become a popular form of transportation, allowing people without automobiles to experience road travel for themselves. This modern terminal in Bradenton was a stopping point for Tamiami Trailways.

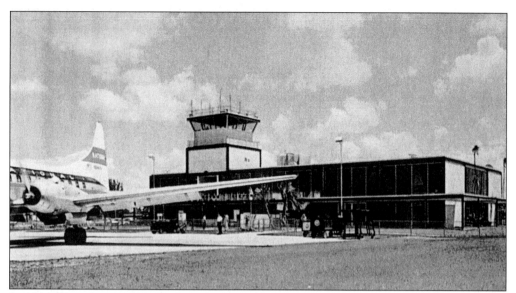

In 1914, Tony Jannus flew the first plane into Sarasota from Bradenton in a 27-minute flight. The area's first official airfield was cleared by local residents when a Community Work Day was called in 1918 to create an emergency landing field for army airmen. The current airport, between Sarasota and Bradenton, was the first with an observation deck, which thrilled the local children.

This National Postcard Week card, designed by S.D. Bartlett in 1985, shows the Scottish encountering poor living conditions in the 1880s. Plentiful fishing and free-range farm animals are noted, as are Sarasota's welcome to tourists and the circus's winter quarters.

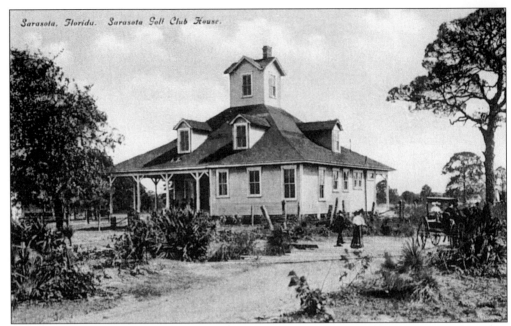

The Sarasota Golf Club House was built when golf became a popular sport in the early 1900s. An attractive brochure from the Florida Mortgage and Investment Company had lured many families from Scotland, which was in the throes of a great depression in the 1880s. John Hamilton Gillespie, a Scottish immigrant, introduced golf to Florida.

Today, Florida is a haven for golfers, and many communities are built around golf courses. The popular sport has come a long way from Gillespie's first practice course on Sarasota's Main Street, consisting of only two greens and a long fairway.

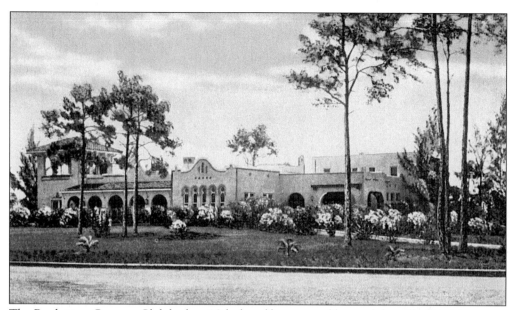

The Bradenton Country Club had an 18-hole golf course and boasted that all of its drives were "beautified with Australian pine trees, shrubbery, hibiscus and many other flowers." The club also hosted dinner dances and afternoon teas.

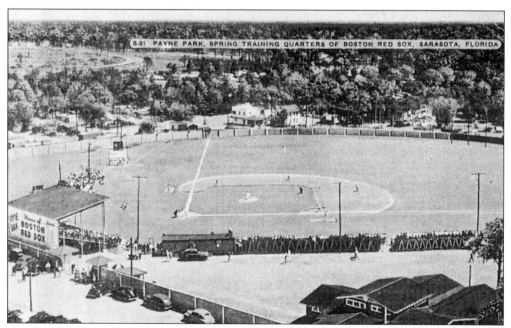

Payne Park, adjoining the Sarasota Mobile Home Park, was the spring training headquarters of the Boston Red Sox for many years as this 1940s postcard shows. The Chicago White Sox replaced them and still hold exhibition games at Ed Smith Sports Complex in March and April. Today, most of this area is filled with city buildings.

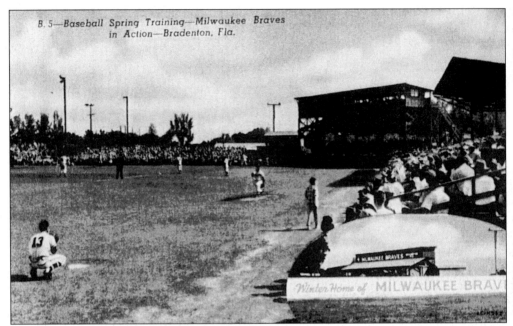

From 1930 to 1936, the "Gas House Gang," as the St. Louis Cardinals were known, trained in Bradenton. The Milwaukee Braves are shown here in action in the 1940s. These days, Pirate City is the spring training camp of the Pittsburgh Pirates, and games are played in March and April at McKechnie Field.

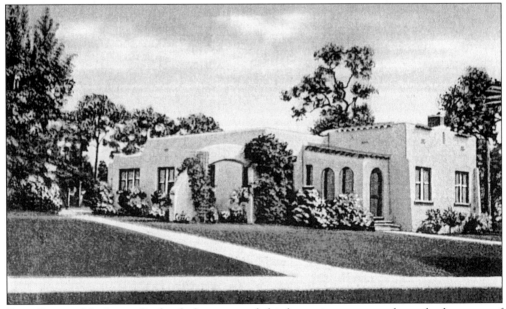

Dizzy Dean, of St. Louis Cardinals fame, owned this home in an upper-class suburban area of Bradenton. When he wasn't on the ball field, he fished in the Manatee River and Palma Sola Bay within a short distance of his house.

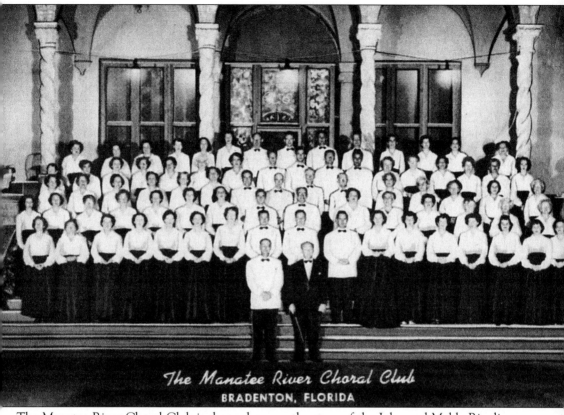

The Manatee River Choral Club
BRADENTON, FLORIDA

The Manatee River Choral Club is shown here on the steps of the John and Mable Ringling Museum of Art. The group was quite well known during the 1940s and 1950s. The 100-voice Choral Club recorded for RCA-Victor and was directed by Lou Jackobson, one of the country's outstanding theatre organists. The club was popular with Florida residents as members toured the state and performed a series of concerts annually in several Florida cities. The auditorium at Memorial Pier in Bradenton was the site of a national radio hookup, and the Manatee River Choral Club could be heard from coast to coast.

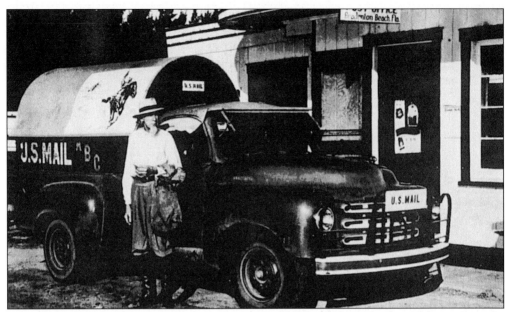

In 1915, Bradenton's first mailman began his route. This Bradenton Beach mail carrier brought his little dog with him each day; the back of his truck sported a cage. Clara writes, on the message side of this postcard, "This is the picture of the mail carrier but he is not wearing his pretty striped pants."

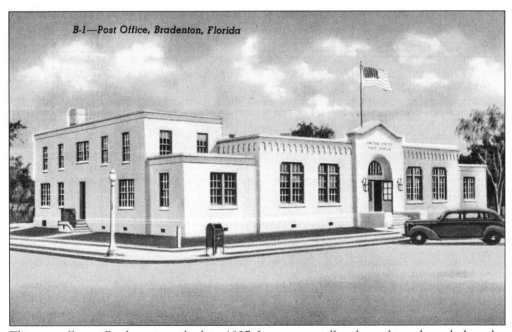

This post office in Bradenton was built in 1937. Its corner mailbox has a drive-through drop slot for the convenience of those traveling by automobile. Note that it was accessible only to the passenger side. The town has had two female postmistresses.

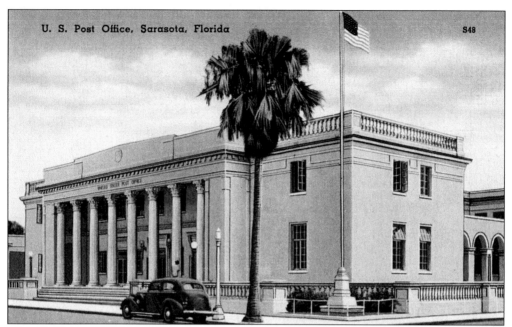

The Social Security Administration now occupies this post office building in Sarasota. Built in the days before air conditioning, its windows are open to the gulf breezes. The eight stone columns add an air of formality to the structure.

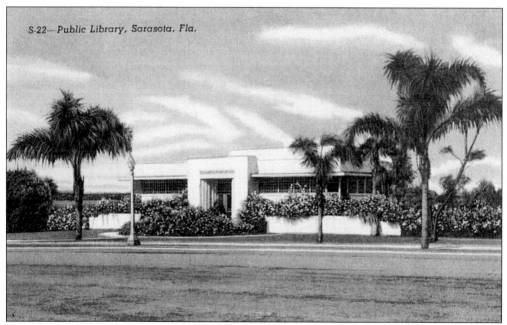

This library in Sarasota is now used to restore damaged books within the library system. The Selby Library was built for public use; now it has been closed and a newer library has opened downtown near Five-Points.

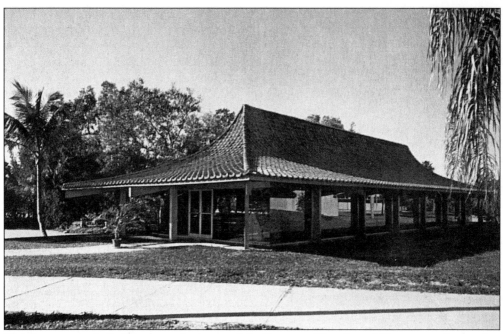

This Japanese-style building was the home of the Sarasota Chamber of Commerce. Located at the civic center, it was next to the library, exhibition hall, and the shuffleboard courts. Today, it is a tourist information center, distributing information to thousands of visitors each year.

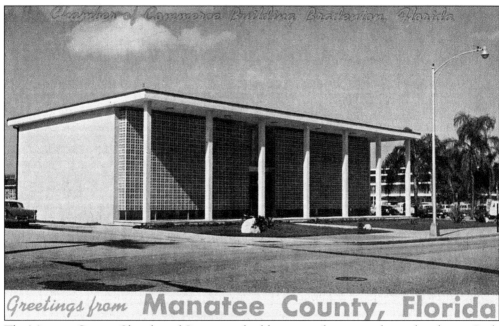

The Manatee County Chamber of Commerce building is much more traditional in design. Built in a 1950s style, its modern streetlights brightened both the street and parking area.

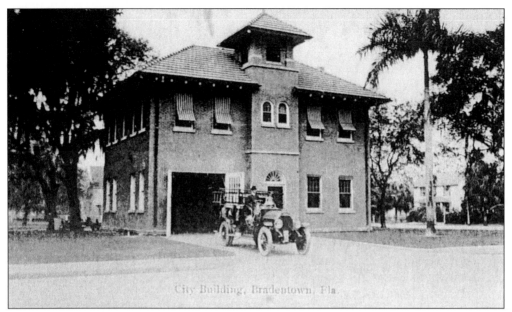

Bradenton's city hall shared a building with its fire department on Thirteenth Street West, across from the offices of the *Bradenton Herald*. Later, they moved to separate buildings. In 1914, due to several fires, the city council ordered a $9,000 combination chemical pump and hose truck for firefighting. The truck shown has right-hand drive and a large bell in front.

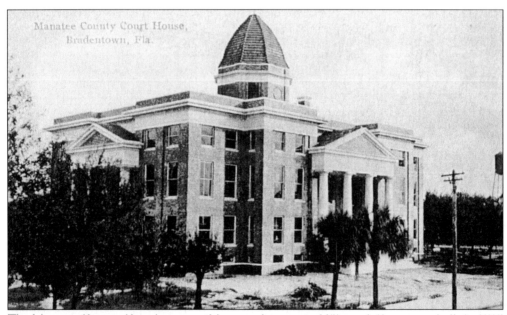

The Manatee County Courthouse, on Manatee Avenue and Fifteenth Street, was built in 1860 and was moved four times. It is the oldest remaining county courthouse in Florida built explicitly for that purpose. Later, it served as a church, parsonage, and private residence.

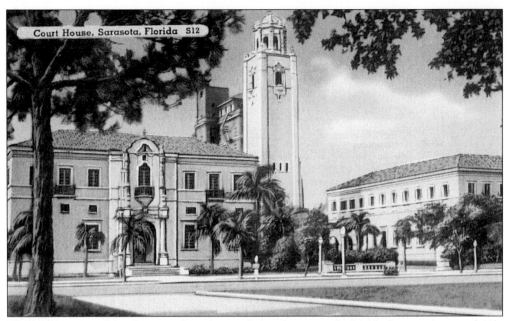

This 1940s view of the Sarasota Courthouse shows the way it looked before it was completely refurbished. The sunken garden in the courtyard has been the scene of at least one wedding ceremony. The bell tower has had its bells restored, and the tile roof has been replaced.

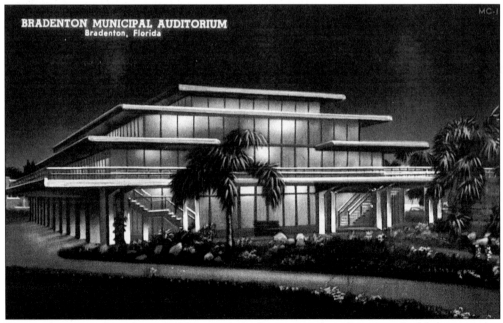

This night view of Bradenton's Municipal Auditorium makes the entire building appear to glow. Such views were popular in the 1930s and '40s to impress people with the cosmopolitan look that modern lighting provided to the area.

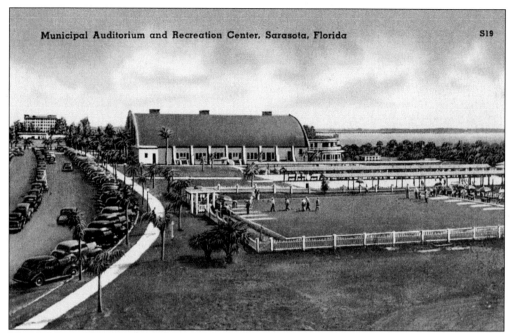

The Sarasota Municipal Auditorium and Recreation Center boasted nine tennis courts, 40 shuffleboard courts, bowling on the green, card rooms upstairs for bridge, croquet, roque, archery ranges, and putting greens. It was built in 1939 at a cost of $250,000.

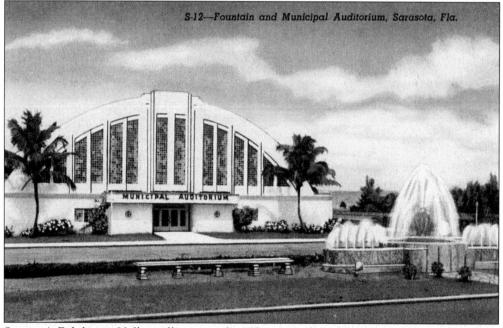

Sarasota's Exhibition Hall is still in use today. The original art deco fountain was purchased by volunteers for the Ringling Museum. In the 1980s, it was installed at the front of the museum. Later, the fountain was moved back to the Exhibition Hall. The Municipal Auditorium was the site of Easter egg hunts in years past.

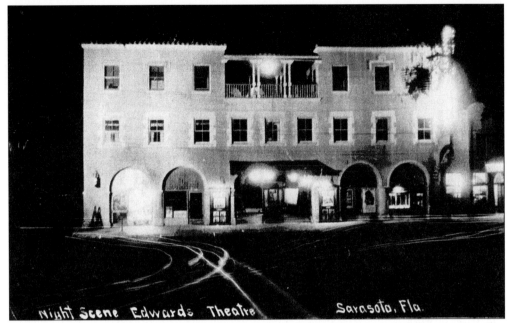

Edwards Theatre, at 57 North Pineapple Avenue in Sarasota, opened in 1925 to a capacity crowd of 1,500. In 1929, it premiered the locally filmed *Sarasota's Hero*, the first of many films shot in the area. The theatre, which cost $350,000 to build, was called "The Temple of Silent Art and Make Believe." Renamed the Florida Theatre, it is now Sarasota Opera Hall.

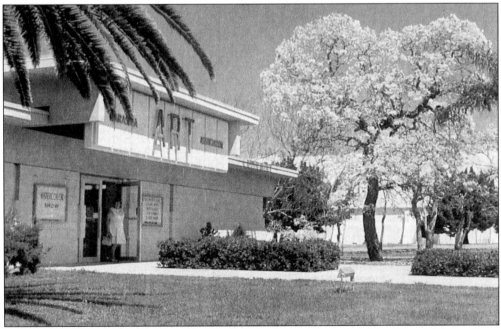

The Sarasota Art Association Building, which was located next to the library in the Civic Center, still hosts arts and crafts shows. A watercolor show was on exhibit when this view was taken in the early 1960s.

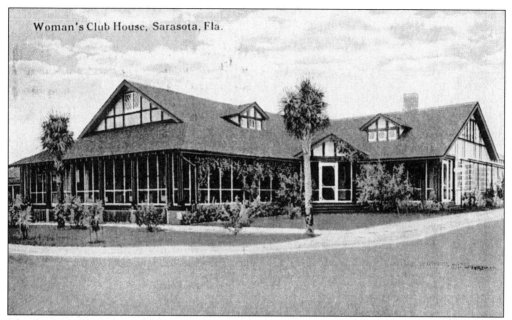

The Sarasota Woman's Club on Palm Avenue, built in 1915, became the Florida State Theatre in 1979. From its beginning in 1903 as the Town Improvement Society, the Woman's Club has played a major role in city betterment. On this postcard, mailed in 1922, N.R. writes to Jenette in Ohio, "A very beautiful town of 3000 population . . . the people are fine down here."

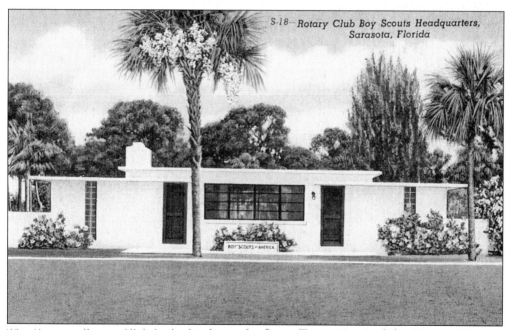

The Sarasota Rotary Club built this home for Scout Troop No. 6 of the Sarasota District, Sunnyland Council, Boy Scouts of America, in 1941. The building was located in Gillespie Park. The Rotary Club sponsored this troop.

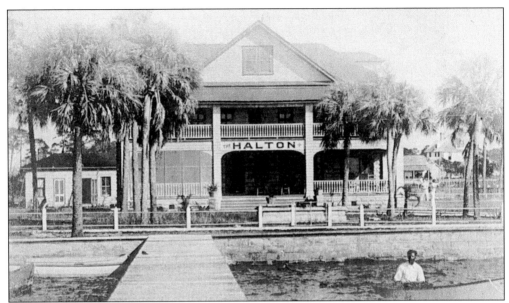

Dr. Joe Halton's elegant sanitarium was built on the bayfront in 1908 and served as Sarasota's first hospital. Due to a shortage of hotels, Halton's Sanitarium was often used as guest quarters for visiting, wealthy dignitaries such as Mrs. Potter Palmer. Dr. Joe ran a one-man campaign for installing sewers and eliminating privies in the business district. In 1921, he opened a seven-bed, private hospital downtown.

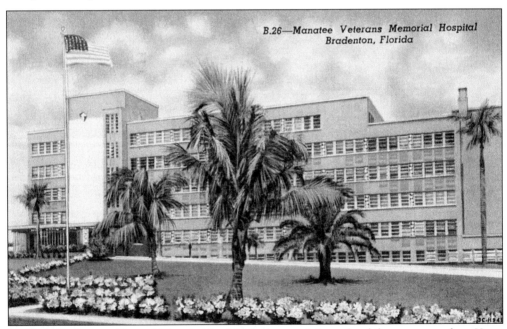

In 1925, Bradenton General Hospital had 32 beds, a training school for nurses, and an X-ray machine. A bigger hospital was needed, and the Manatee Veterans Memorial Hospital, dedicated in 1953, was built largely by public subscription. Renamed Manatee Memorial Hospital, the building soon became too small to handle the growing population, and several additions were built.

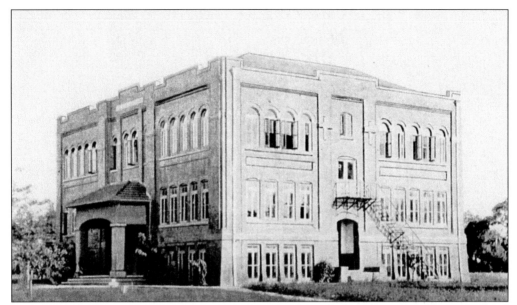

As Manatee grew, more and more families moved to the Bradenton area. Additional school facilities were needed, and the Manatee Graded School was built in the early 1920s. It sported a modern fire escape, and the upper windows were often open to cool the upper floor.

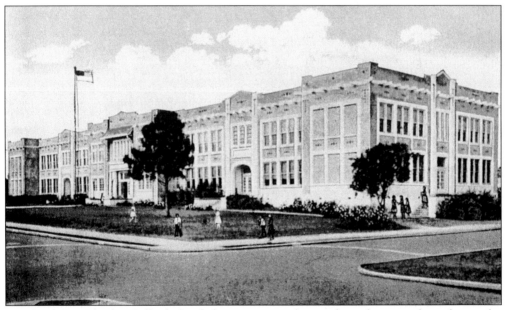

In 1892, Dr. Charles Ballard decided to motivate his students by rewarding those who performed extremely well at school. He awarded vacant plots of land to the 15 students with the highest grades. Then Dr. Ballard underwrote the cost of a new school. This building, named in his honor, became Bradenton High School.

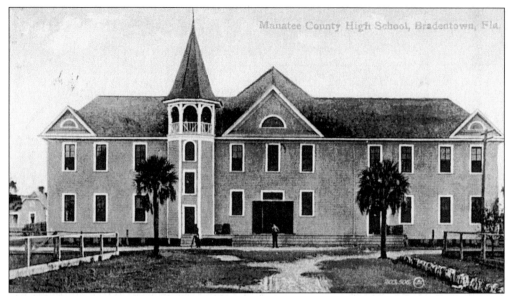

This 1909 view shows the original Manatee County High School building. The school had a basketball team, and its football team won the state championship in 1915. It was during that year that Bradenton High School and Palmetto High School merged into Manatee County High School.

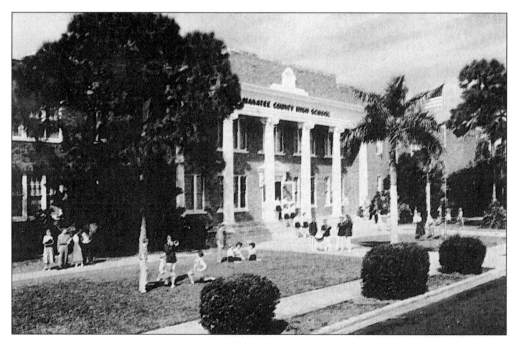

In 1954, Manatee County High School's yearbook was named "The Manatee Leaves." Published in color, it was sponsored by the Manatee River Bank and Trust Company. About 900 students attended the school in the late 1950s. Vocational, academic, and commercial courses were available.

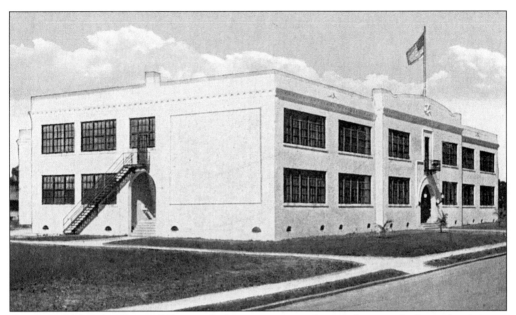

Caroline Abbe, daughter of Sarasota's first postmaster, began the town's first school in an abandoned fishing shack in 1878. The first frame school was built in 1904; it had 124 pupils and four teachers. Sarasota Primary School was built in 1913 at a cost of $23,000 on the same lot. It boasted 11 classrooms and an auditorium. Students ranged from elementary through high school, and its first graduating class consisted entirely of girls.

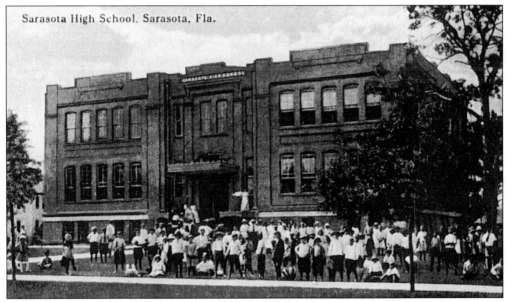

Sarasota's first high school was built of brick. This postcard, c. 1910, shows many of the community's children posing on the lawn. The high school soon became the pride of the community.

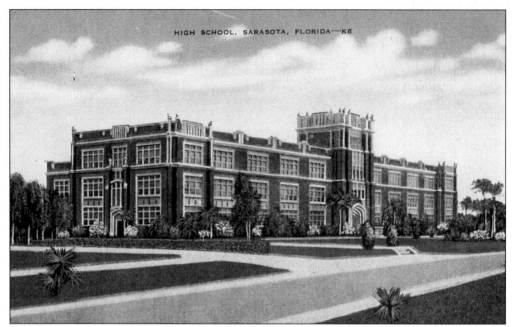

Population growth necessitated a new high school in Sarasota, and one was built in 1927 for $317,000. A showplace, it contained art and statuary that is now displayed in the Ringling Museum. Its sports teams' names came from the days before there was a bridge to Tampa. In order to play Tampa's teams, Sarasota players had to travel by boat . . . and they were dubbed "The Sailors."

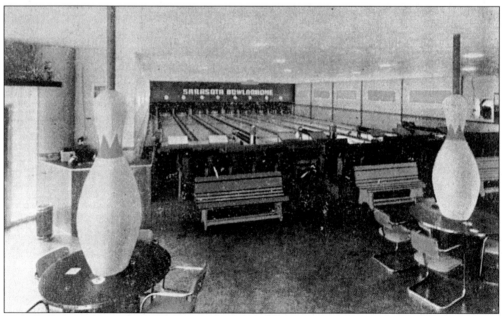

The newest popular sport in the 1930s was bowling, enjoyed by teenagers as well as adults. The Sarasota Bowladrome at Fifth and Pineapple is shown in the 1940s. The modern bowling palace sported automatic pin re-setters and provided fun for one and all.

Four
THE TOURISTS ARRIVE

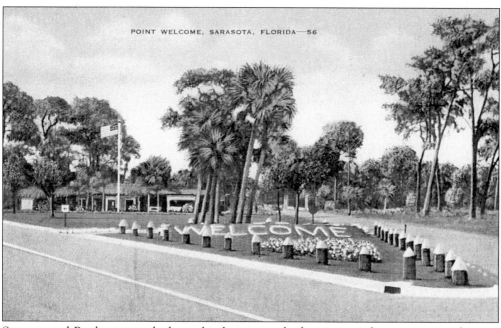

Sarasota and Bradenton worked very hard to attract both visitors and permanent residents to the area. Many came "just for the winter," fell in love with the area's beauty, climate, and friendly people, and stayed on to build businesses and raise families. In 1926, the Sarasota Chamber of Commerce produced a postcard folder, distributed to people inquiring about the area. "We wish that we could say 'hello' and back it up with a warm handclasp of the kind that is typical of the general hospitality that permeates Florida, and Sarasota in particular," the card reads. " . . . you can get in your automobile, or load your luggage and self on to one of the many luxurious and comfortable trains, come to Sarasota and enjoy the winter as cheaply as you can buy coal, winter clothing, and other commodities made necessary by the piercing blasts of cold weather, with its attendant discomforts and ailments." Point Welcome, operated jointly by the American Legion and the City of Sarasota, was located at the Sarasota County entrance to the north. Visitors were served orange juice and given a cordial welcome.

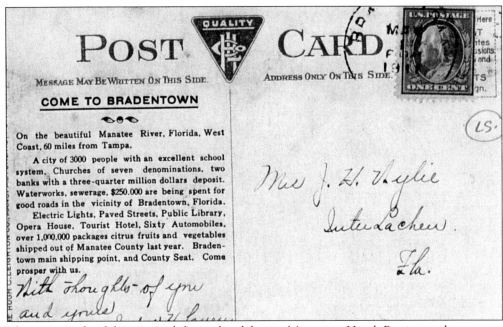

The picture side of this postcard shows the elaborate Manavista Hotel. But it was the message side, mailed in 1911, that provided the sales pitch for Bradenton and Manatee County.

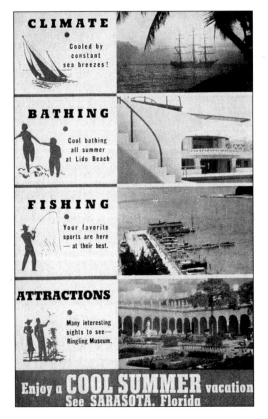

This 1940s card was produced by the Florida Power and Light Company. The "Summer-Gram" called Florida "The Water-Cooled Vacation Land" and touted its climate, Gulf of Mexico bathing, sports fishing, and many attractions, including the Ringling Museum.

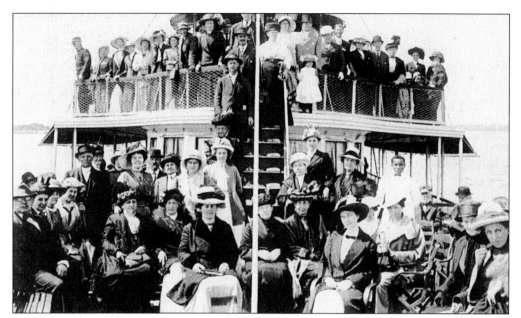

And come they did! Many happy visitors arrived by steamer. The Favorite Line, formed in 1907, included *Favorite*, *Hanover* (nicknamed "Hangover" because of its tendency to run aground), *H.B. Plant*, and *Terra Ceia* (called "Bull of the Woods" due to its being hard to steer).

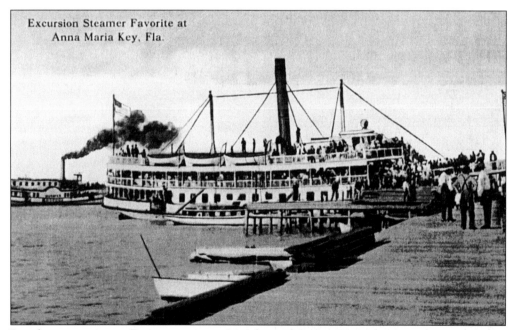

Regular excursions on *Favorite* ran every Monday and Friday. For an 81¢ round trip, a traveler could leave St. Petersburg in the morning, have an excursion and picnic on Anna Maria Island's beach, and return in the evening. Steamer traffic declined sharply with the advent of good roads and increased railroad service.

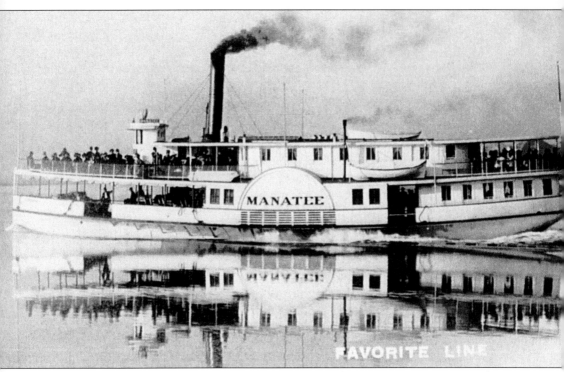

The *Manatee* transported both passengers and freight between Tampa, St. Petersburg, towns along the Manatee River, Sarasota, and Ft. Myers. The steamer, built in 1885, was 125 feet long and 32 feet wide, and could travel 10 miles an hour when fully loaded. In 1909, The *Manatee* became part of the Favorite Line when it purchased the Independent Line. The *Manatee* made frequent stops at the tomato plant on the Cut-Off to pick up packed vegetables and deliver supplies. It also stopped at the Palma Sola Wharf, where a white flag flying was the signal that some freight or a passenger was ready to board. The ship changed hands many times over the years and was finally taken out of service in 1928.

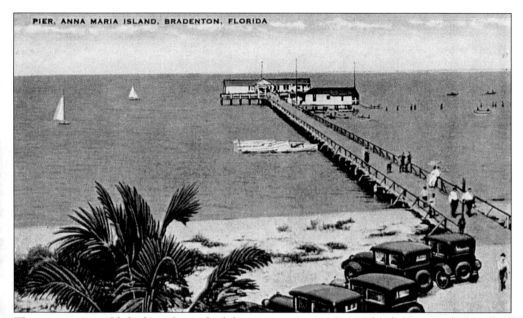

The steamers would dock at the end of the pier on Anna Maria Island. Visitors then walked down the boardwalk to the 10-mile, fine white sand beach to spend the day swimming, sunning, boating, or fishing. Hard-surface roads connected Anna Maria to the city of Bradenton.

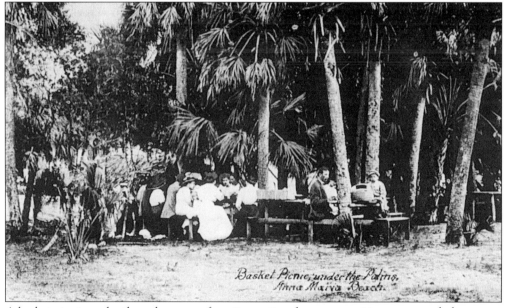

A basket picnic under the palms was a favorite pastime for steamer visitors, many of whom were on day excursion trips from Tampa and St. Petersburg, across Tampa Bay.

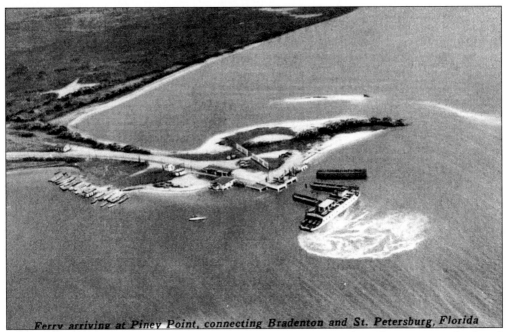

Ferry arriving at Piney Point, connecting Bradenton and St. Petersburg, Florida

The Bee Line Ferry and the St. Petersburg Port Authority Ferry brought passengers back and forth between Bradenton and St. Petersburg. Crossing Tampa Bay, they docked at Piney Point. Boats left every 30 minutes during the winter season and every 45 minutes during the summer.

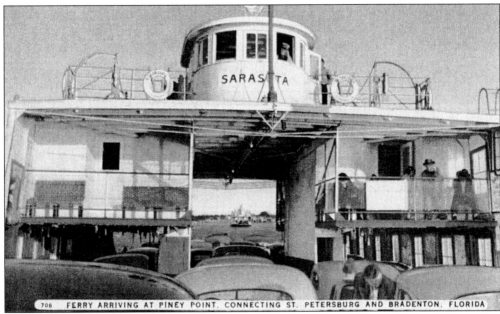

706 FERRY ARRIVING AT PINEY POINT, CONNECTING ST. PETERSBURG AND BRADENTON, FLORIDA

Riding the ferry was a popular outing during the 1940s. Live bands kept the passengers entertained during their journey. Transporting a car this way saved 49 miles of driving. The ferries finally stopped running after the Sunshine Skyway Bridge was built, connecting St. Petersburg to Bradenton.

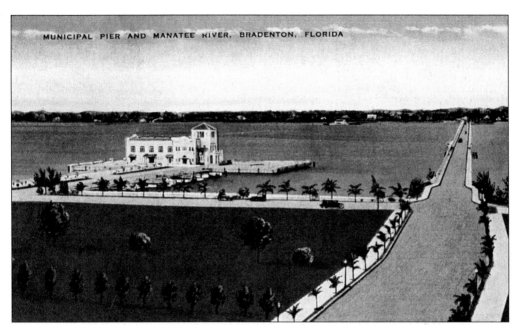

Completed in 1928, the Municipal Pier on the Manatee River, building, and boulevard cost the City of Bradenton $300,000. The construction was a campaign promise of Mayor Whitney Curry, who wanted to replace the broken-down wooden dock at the foot of Main Street. The building, with outside stucco, was the Chamber of Commerce headquarters complete with auditorium seating for 800 and room for dances and meetings.

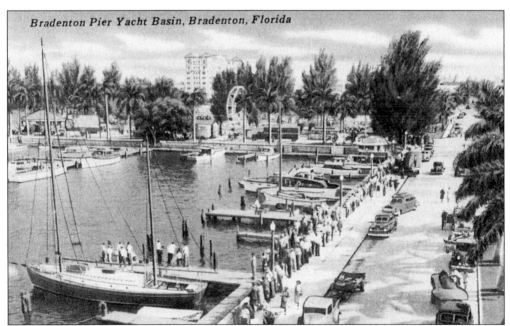

On October 10, 1929, the pier was dedicated and officially named Veterans Memorial Pier. Plaques showing the names of soldiers lost during WW I were placed along the boulevard. The original pier is still in use today. This view of the yacht basin shows a ferris wheel in the background.

The beaches, with their fine white sand, were a major attraction to visitors. Of course, the lovely young ladies in their bathing suits also attracted the young men and vice versa. This 1950s postcard is an example of the "Florida bathing beauties" featured in many tourist brochures.

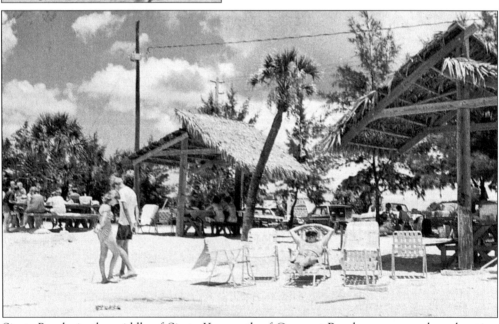

Siesta Beach, in the middle of Siesta Key north of Crescent Beach, was a popular relaxation spot. The tiki huts were hand-made from palm frond thatching. Siesta Key was formerly known as Sarasota Key; it was renamed Siesta in 1907 by Harry Higel, the developer who erected its first bathhouse. Its fish market is a reminder of the area's history as a fishing village.

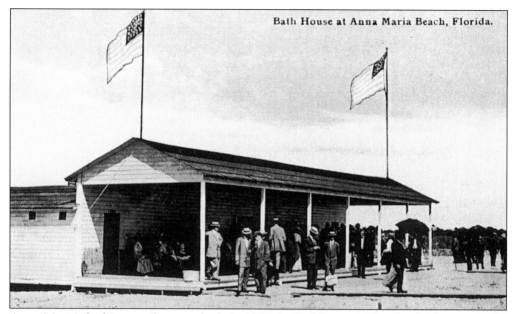

Anna Maria's bathing pavilion was built in 1910. Its bathhouse, said to be the largest on the Gulf of Mexico, had cubicles for changing clothes. In 1922, the Cortez Bridge opened and people could drive to Anna Maria. Big Apple Contests, with blaring Saturday night bands and two lines of dancers facing each other, awarded prizes to the most innovative dancers.

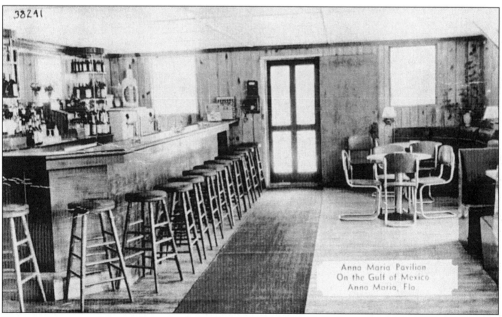

The pavilion was always a hangout for young people. The 1940s brought the Lindy Hop, as well as WW II. During the war, the pavilion served beer and mixed drinks "right on the beach." It also became a spotter barrack for sighting enemy planes. In 1946, a fire consumed the pavilion. It was rebuilt and has changed hands several times, but it is still the liveliest spot on the island.

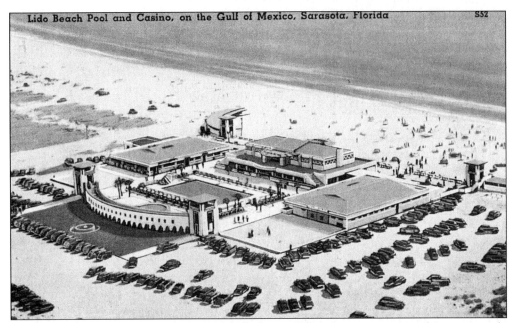

Sarasota's Lido Beach Pool and Casino was built as a WPA project at a cost of approximately $250,000 and opened on December 27, 1940. With its pale pink cabanas, colorful awnings, tea dances in the big ballroom, bands, and swim meets, it was the gathering place for all the kids in town.

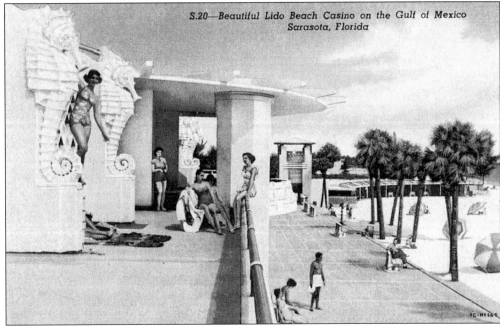

In the days of legalized gambling, the casino was called "Shadowland." Famous for its tall towers, marking each corner of the white stucco complex, and its giant sculpted sea horses, the Lido Beach casino was perched on 1,300 feet of beachfront land. The building was torn down in the 1960s.

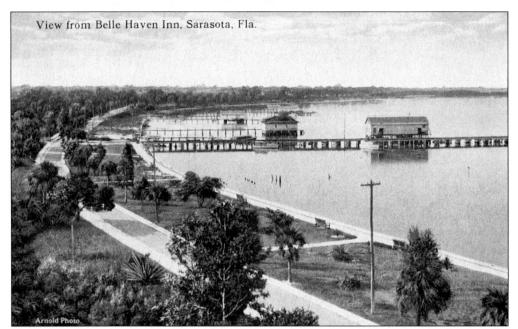

The beautiful waterways of the Sarasota-Bradenton area have always attracted fishermen, both commercial and sport. This Sarasota view, c. 1915, shows the docks where fishermen could spend quiet afternoons. The waterfront greenery has since been replaced by commercial buildings.

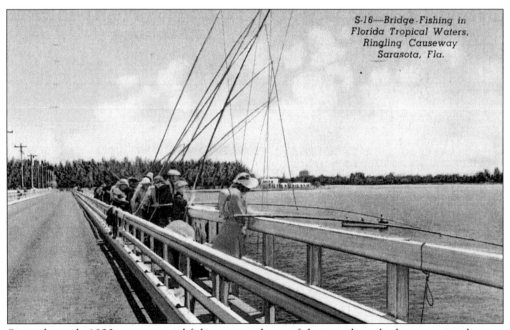

Since the early 1920s, commercial fishermen and sport fishermen have had an ongoing dispute. Tourists say that netting ruins the sport, while commercial fishermen claim to need netting to catch mullet, which aren't attracted by hooks. Both men and women enjoyed fishing from the Ringling Causeway.

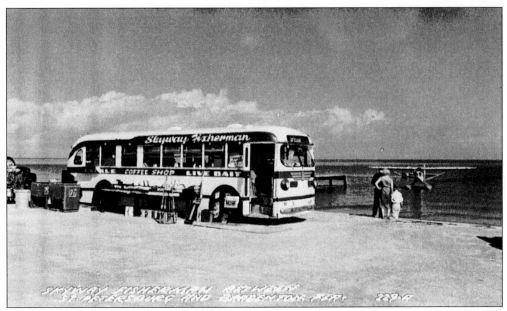

The Skyway Fisherman, between Bradenton and St. Petersburg, was a mobile coffee shop, as well as a live bait and tackle shop. The big 7-Up cooler on the left quenched many a mighty thirst. The small group to the right is gazing at a seaplane in the water.

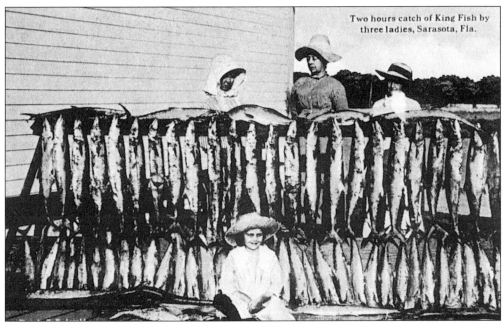

In 1909, Mavis mailed this postcard to Robert in Ohio saying, "This is the way *we* catch fish down here!" This is a fine kingfish catch by any standards. One wonders if the little girl in front went fishing too, or just enjoyed having her photo taken.

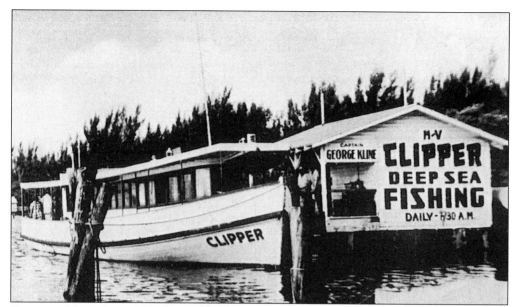

Deep sea fishing boats like this one were available for private rental, as they still are today. Based in Bradenton Beach, the 65-foot clipper featured diesel power, ship-to-shore radio phone, depth recorder, a modern galley, and a snack bar. And, of course, you could keep all the fish you caught.

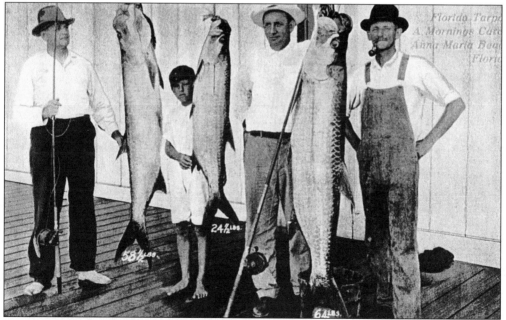

The annual Tarpon Tournament, held near Labor Day, was a huge event. Veterans arrived to make speeches, and families would spend the day picnicking waiting for the ships to come back in. When they did, the tarpon and the people who caught them were lined up for pictures. These three large fish, caught at Anna Maria, weighed 24.5, 58.5, and 64 pounds.

The 1920s, with the growing availability of automobiles, saw the invasion of the Tin Can Tourists. This mode of travel became so popular that the Tin Can Tourist Association was formed. Members in trouble on the road would place a tin can over their car's radiator cap to identify themselves, and passersby would stop to help.

Crank up the Lizzy, an' all git aboard,
 We're goin' down south, so hurry up an' load!
I know she rattles, an' the radiator leaks!
 But she'll git us thar safe, even if she squeaks!
Git the axe an' saw, an' the big fryin' pan;
 An' the tent an' pegs. An' oh, my lan'!
Don't forgit the matches, an' the ole tire pump!
 Hustle around now, an' keep on the jump!
The weather-man says, thar's a blizzard comin';
 So crank up the Lizzy an' keep 'er a-hummin'!
Head 'er fer Floridy, as fast as we can go;
 An' we'll beat that blizzard, first thing we know!
We'll pitch our tent, by a runnin' stream,
 An' the rest of the winter, 'll be one long dream!
 —S.S.R.

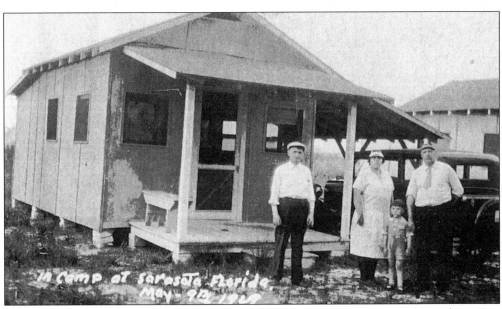

Makeshift tourist camps sprang up overnight. Both Sarasota and Bradenton welcomed Tin Can Tourists and provided them with free or near-free space to stay. Although some thought they were undesirable, many local politicians and business owners appreciated the tourists' healthy bank accounts.

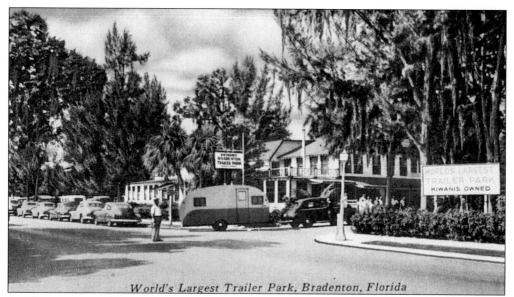

World's Largest Trailer Park, Bradenton, Florida

By the 1930s, trailer parks blossomed everywhere. In 1936, the Bradenton Kiwanis Club decided to build one also. Its moderate rates were used to maintain the grounds, and all additional funds were used for charitable projects. Over the years, thousands of dollars went to organizations and needy individuals. Known as the "World's Largest Trailer Park," it was located on the Tamiami Trail, a mile south of the business section.

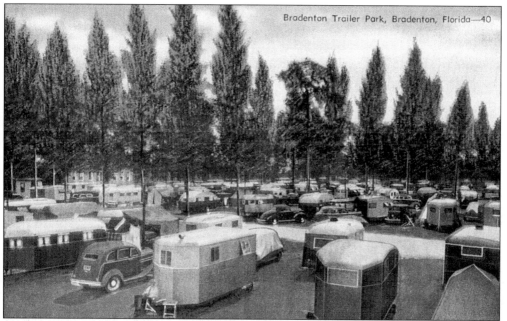

Bradenton Trailer Park, Bradenton, Florida—40

In the 1940s, the park touted electric meters, water piped to each trailer, paved streets, and continuous entertainment. By 1950, the park reached its capacity of 1,190 lots, but, with no planning, it was very cluttered. The year 1966 saw a renovation plan that enlarged lot sizes and reduced the number of lots to 600. In the late 1990s, the Kiwanis were forced to sell the park when the Internal Revenue Service disallowed the club's use of the trailer park for charitable purposes.

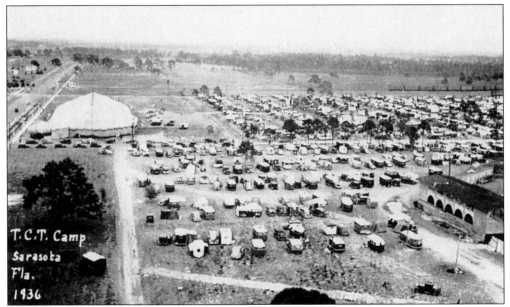

Sarasota's City Trailer Park opened in 1931 on part of a tract that Calvin Payne had deeded to the city for a ball park. National conventions of the Tin Can Tourists (T.C.T.) were held here until 1937. Rent was $5 a space, and there were three community buildings on the grounds, each with six toilets and a washroom. The iceman came through the streets, and stoves ran on kerosene.

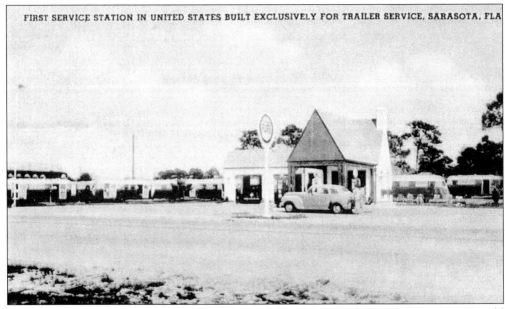

Near the park's entrance at South Washington Boulevard and Laurel Street, McDonald National Trailer Sales opened the first service station in the United States built exclusively for trailer service. The station was a distributor for Pure Oil products.

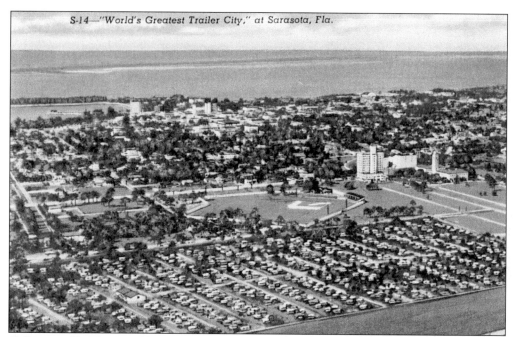

Calling itself "The World's Greatest Trailer City," the park became the largest and oldest municipally owned and operated mobile home park in the country with a "winter trailerite population" of 3,500. The adjoining baseball field has been the spring training headquarters for several teams over the years.

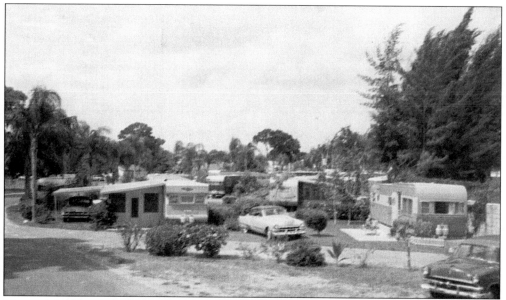

The park had been deeded to the city, which rented it out to be used as a mobile home park. Then the city expanded into it, and much of the area is now occupied by city buildings. Its back side is now Ringling Shopping Center. This 1960s view shows the park with 900 spaces and the slogan, "You're a stranger only once." Today, there are tennis courts, a park, and a jogging trail on the grounds.

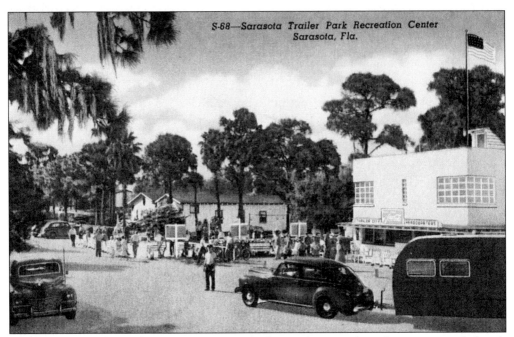

The Sarasota Trailer Park's recreation center had an auditorium for indoor games and church services, shuffleboard courts, card rooms, and horseshoe pitching lanes. Trailer City Headquarters (flag flying) housed a grocery store and a post office substation. In later years, the park boasted a community TV antenna, free movies, and an automatic laundry.

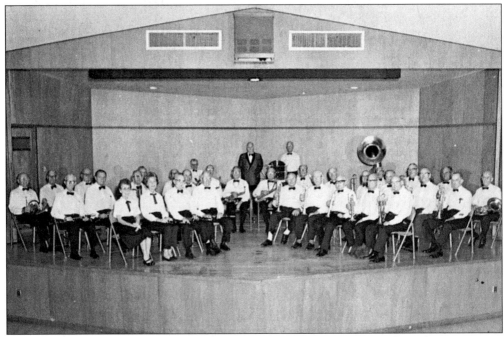

The Sarasota Mobile Home Park Concert Band began playing a series of Sunday concerts in 1932. The average age of the musicians was 78. These men and women went beyond the park's advertisement that "Fishing, swimming and loafing are popular pastimes."

Five
HOTELS, HOMES, AND RESTAURANTS

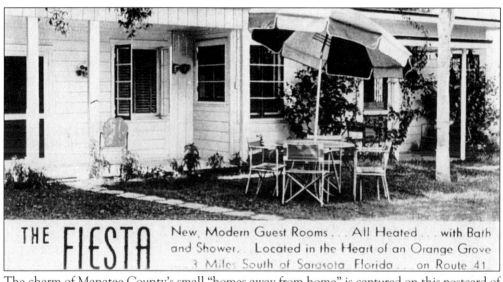

The charm of Manatee County's small "homes away from home" is captured on this postcard of the Fiesta, mailed in 1942. Bob wrote this message to Mrs. Forbes in New York, "... sure have a swell place here. I will probably look like an orange before I leave here." Tourists, as well as an influx of new residents, created a building boom in both Sarasota and Bradenton. Elegant hotels were needed for wealthy visitors. Affordable cottages were built to cater to the middle-class visitors and family groups. Housing developments, apartments, and condominiums sprung up to entice northerners to stay in their vacation paradise permanently. Eateries abounded in great variety for every taste and every budget. From the extravagant to the plain, food was served up with a smile and a kind word for guests far from home. The buildings' exteriors speak to the type of visitor builders hoped to attract. Interior views give us a glimpse of lifestyles of days gone by and furnishing styles of long ago.

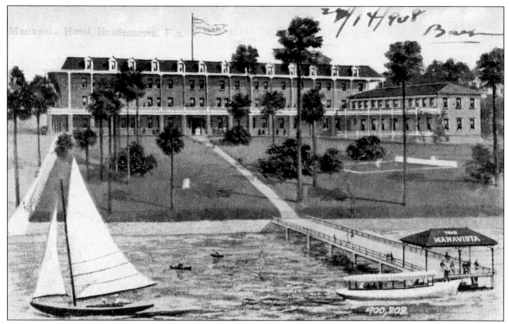

The beautiful and luxurious Manavista Hotel was one of the most elegant in the area. Its rooms, with a view of the water, private dock, and reputation for excellent service, attracted wealthy visitors. The hotel sported its own tennis courts by 1915. This 1908 view shows the hotel from an unusual angle. Today the Cabana Hotel occupies this spot.

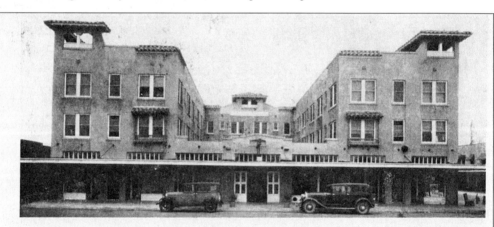

The NEW BAY HAVEN HOTEL, Sarasota, Florida

COOKING PRIVILEGES IF DESIRED	70 ROOMS WITH BATH
City Gas—New Stoves	Rooms with Bath as Low as $6.00 a Week for Two
WE CATER TO TOURISTS	Simmons Beds and Mattresses
You Need Not Unpack—Come In as You Are—FREE GARAGE Next Door To Hotel	"Two Can Sleep as Cheap as One" Room with Bath $1.50 for Two

Sarasota's New Bay Haven Hotel maintained a quiet, refined atmosphere. The address side of this postcard from the 1920s shows a view of the lobby and proclaims, "Hotel Strictly Fireproof—Sprinkler System—Steam Heated." A double room with a bath was $1.50 per night or $6 per week.

The Hotel Sara Sota was located on both the Gulf of Mexico and on Sarasota Bay. It was built by W.H. Pipcorn of Milwaukee, the first man to pay $1,000 a front foot for land in the business section. The hotel opened in 1925 and was Sarasota's first skyscraper. Today, the Sara Sota is a county building and is across from the courthouse.

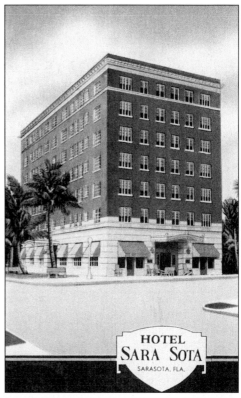

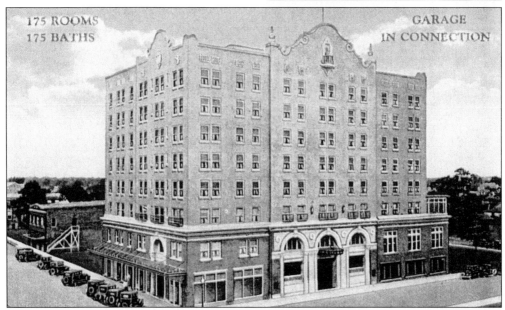

The Dixie Grande was famous in the 1930s for its dining room. A full course dinner with appetizer, entree, potato, vegetables, salad, dessert, beverage, and bread cost 75¢. Members of the "Gas House Gang," the rowdier members of the St. Louis Cardinals, were known for playing tricks on each other and other hotel guests. The Dixie Grande was demolished in 1974, and many residents watched the dynamite blast with mixed emotions.

The Manatee River Hotel, on Tenth Street overlooking the Manatee River at the Bradenton entrance to the Green Bridge, opened in 1926. Management was proud to host many prominent people. Stevenson's, an exclusive ladies shop, as well as a gift shop were inside the building.

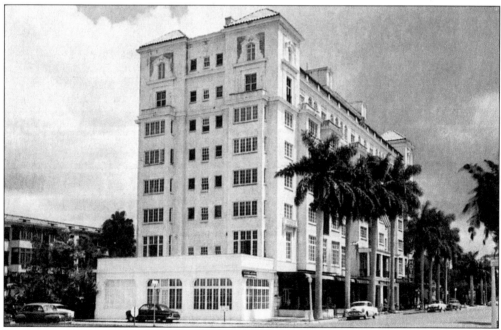

By the late 1950s, the hotel had undergone extensive renovations. Open all year, it featured "modern, air conditioned cocktail lounge, restaurant and rooms." Commercial rates were offered to business travelers. Today, the building is known as the Manatee River Retirement Hotel and Apartments.

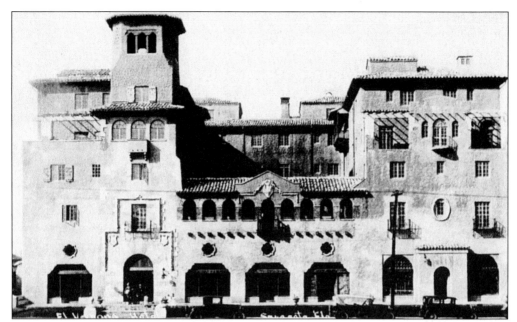

The El Vernona Hotel, designed by architect Dwight Baum and built by Owen Burns, opened with a grand ball on New Year's Eve, 1926. Its lovely Spanish architecture earned it the title of "Aristocrat of Beauty." Its destiny was to become a historic site and then to be torn down.

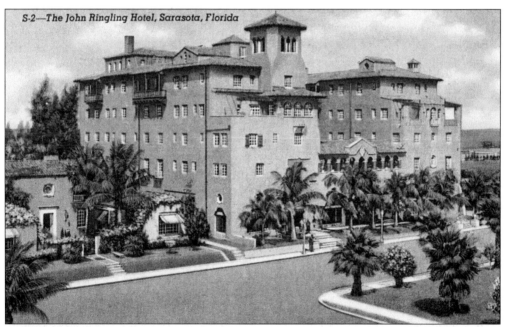

John Ringling acquired the El Vernona in the 1930s and renamed it the John Ringling Hotel. It was operated by his nephew, John Ringling North, and it became the social center of Sarasota. In 1944, North opened the M'Toto Room, a nightclub where guests could stay past daybreak. Celebrities, politicians, and the Boston Red Sox often stayed in the hotel. In 1951, it was the headquarters for Cecil B. DeMille, the cast, and the crew of the movie, *Greatest Show on Earth*, filmed in Sarasota and starring Charlton Heston.

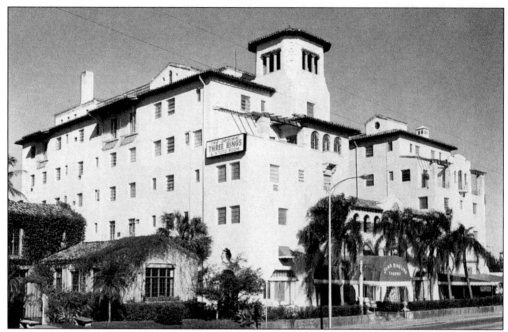

In the late 1950s, the hotel closed, reopening in 1964 as John Ringling Towers, an exclusive apartment hotel with unique penthouses. The Towers became vacant in the 1980s. In spite of being placed on both the Sarasota and the National Historic Register, the property remained vacant, changed hands several times, and was demolished in 1998.

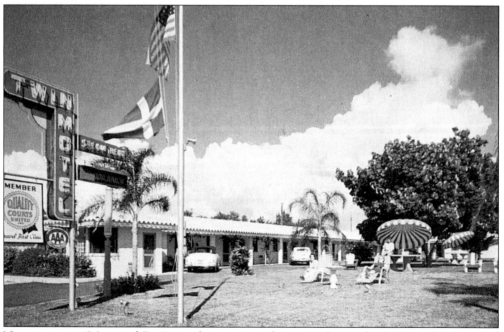

New, compact "Mom and Pop" motels came into their own during the 1940s and 1950s. The Twin Motel on Tamiami Trail offered both hotel rooms and kitchenette apartments, air conditioning, and television. A member of Quality Court United, the Twin was also AAA recommended.

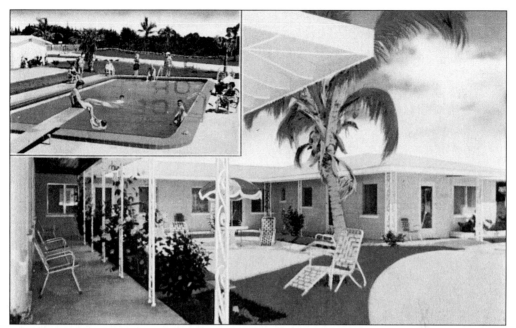

The Blue Horizon vacation apartments on Siesta Key featured one- and two-room, furnished, air conditioned apartments with kitchens, a private beach on the Gulf of Mexico, and an underwater-illuminated swimming pool. This type of motel is rare now since it would be too small to be profitable given the high cost of the land.

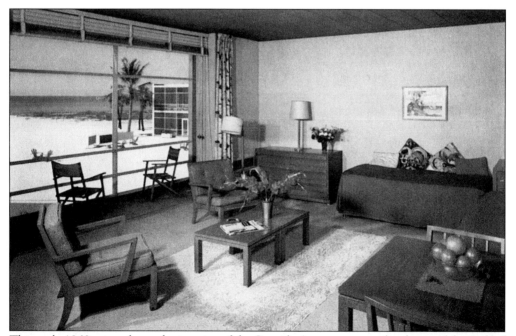

This early 1960s view shows the interior of the Suntide Apartments on the shores of the Gulf of Mexico at Lido Beach. "Outdoor Living Indoors" was its motto. Floor to ceiling rolling glass doors converted a 16-by-20-foot living room into a 16-by-20-foot screened porch, where visitors could look out onto the beach.

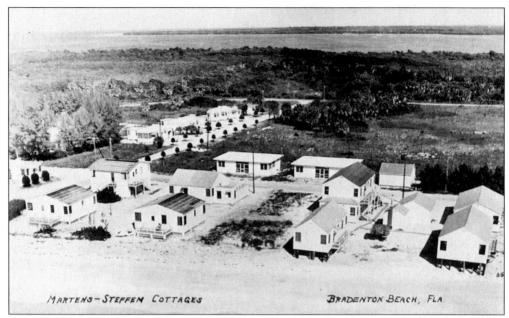

This air view of Martens-Steffen Cottages on Bradenton Beach shows the greenery that used to fill the area. The cottages were raised on stilts to protect them from flooding, and balconies provided beach views.

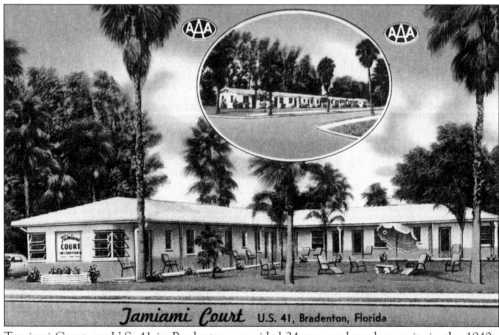

Tamiami Court, on U.S. 41 in Bradenton, provided 24 new and modern units in the 1940s. Radios were free and air conditioning was optional. AAA recommended, the motel's tall palm and pine trees made it a stereotypical Florida vacation hideaway.

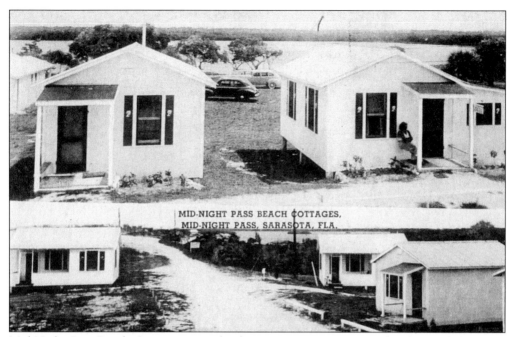

Mid-Night Pass Beach Cottages at Midnight Pass, Sarasota, sat on a hard-packed dirt road. Right on the beach, the cottages offered a Frigidaire (a popular brand of refrigerator) and gas for cooking, fishing, bathing, and shelling. The main office is shown at the upper right.

Proud of their "completely modern electric kitchen" facilities, the Cheeri-Ho Cottages were located on Longboat Key, Sarasota. A toaster can be seen on the shelf above the stove.

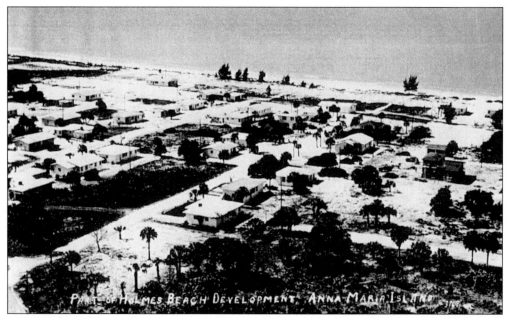

Housing developments boomed, especially on choice property close to the Gulf of Mexico. Anna Maria, at the northern tip of the barrier islands, was a natural spot for early development due to steamer and ferry traffic. Holmes Beach, at the southern end of the island, was the site of the community pictured here.

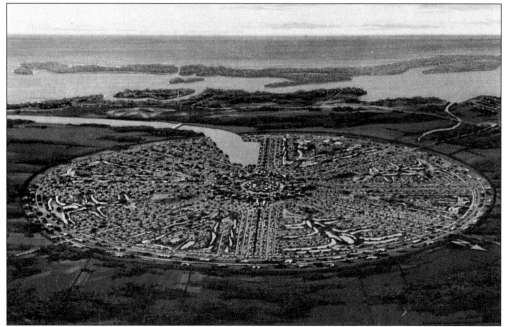

The only planned community in the round, Rotonda West took advantage of the waterways to create a unique living area. This postcard shows a photograph of the architect's scale model, prior to actual construction. Forty miles south of Sarasota, eight residential segments radiated from a center core zoned for business. Seven golf courses, seven marinas, and 32 miles of recreational waterways were designed.

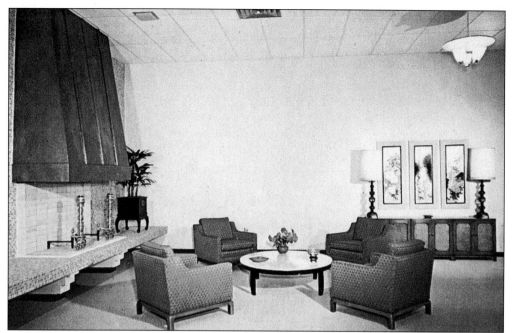

The Sunshine State had long been a popular area for retirees. Bradenton Manor was the first unit of the Presbyterian Homes of the Synod of Florida. The corporation was chartered in 1954 as a nonprofit private organization. In 1961, the first residents moved into the retirement home, which provided hotel-type facilities for 160 people. The attached health center had 20 nursing beds.

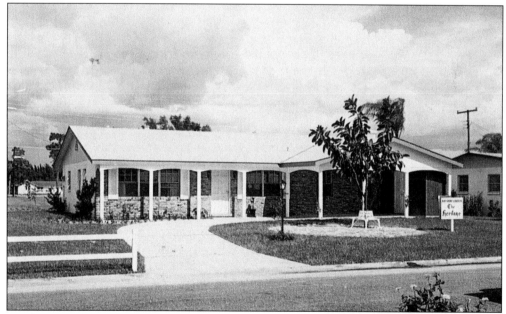

Bayshore Gardens was a professionally planned community with paved streets, sewer, water, and a recreation center. A huge development consisting of houses, apartments, and condominiums, Bayshore Gardens is still a residential neighborhood. The Heritage, a three-bedroom, two-bathroom house, was priced at $16,590, including the lot.

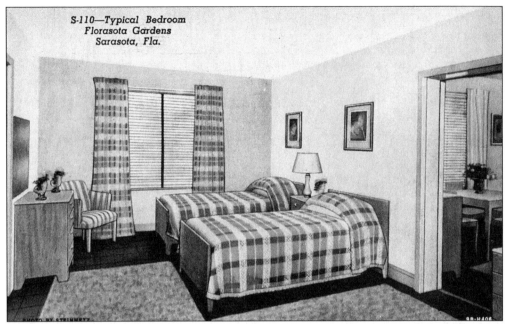

Another well-known Sarasota subdivision was Florasota Gardens. Just 1 mile from the business center, many of the homes faced Hudson Bayou overlooking Sarasota Bay. The streets and grounds were elegantly landscaped with tropical palms and flowers. A freshwater swimming pool fed by artesian wells overlooked a lagoon.

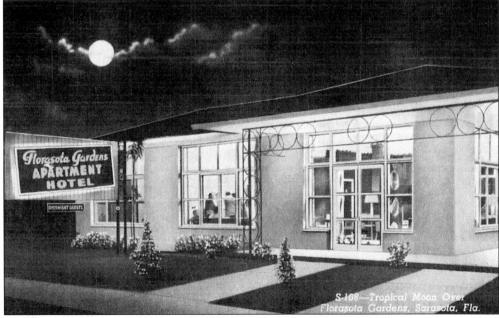

A cottage colony with 200 cottages and hotel rooms, the Florasota Gardens Apartment Hotel was at the conjunction of U.S. 41 and 301. By 1952, it had become Florasota Gardens Shopping Center, a business complex filled with doctors' offices and shops. Local residents flocked there to take advantage of this first place to offer Dr. Salk's new polio vaccine, available on sugar cubes. Today, a new condominium complex is located on this site.

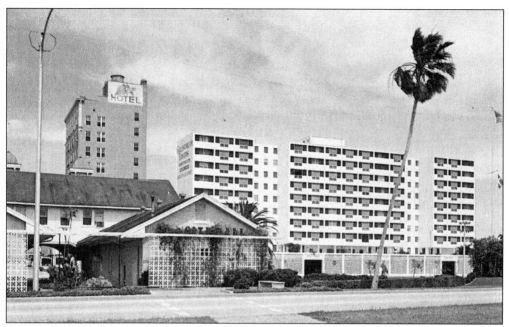

Tall condominiums have become commonplace all along the Florida coast, and the Sarasota-Bradenton area has been no exception. The upper stories offer waterfront views, and the large complexes accommodate both seasonal and year-round residents. This view, from the late 1950s, shows Sarasota's city hall, the Orange Blossom Hotel, and Gulfstream Towers.

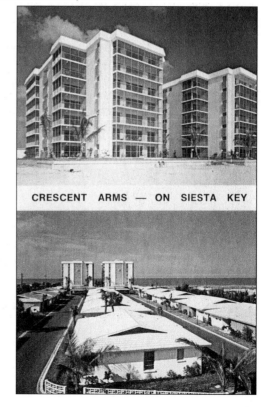

The Crescent Arms complex, on Midnight Pass Road on Siesta Key, offered both apartments and villas. Its location right on the Gulf of Mexico beach made it very desirable, as did its motto, "Luxury You Can Afford." This community is still there, though its buildings have been remodeled.

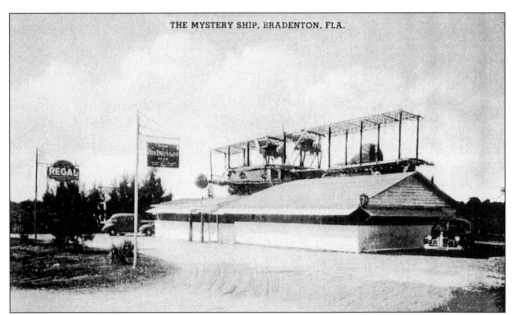

A large restaurant industry developed to serve the influx of tourists and residents. One of the most popular spots in the 1920s was the Mystery Ship Restaurant on U.S. 41 south of Bradenton. This little wooden eatery had a seaplane perched on the roof. Its owner would never reveal how it got there, adding to the fun. The Village Barn stands on this site today.

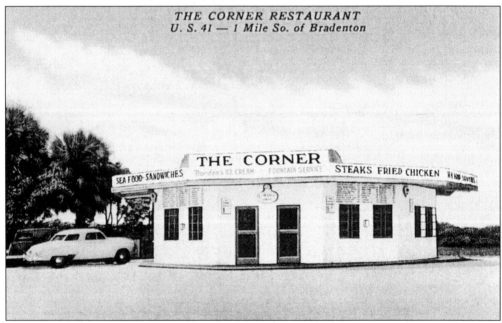

The Corner Restaurant, at the corner of Bradenton Beach Road, painted its menu on the outside wall over its windows. Offering everything from fried chicken to seafood, fountain service to Borden's ice cream, The Corner provided curb service as well as dining room service.

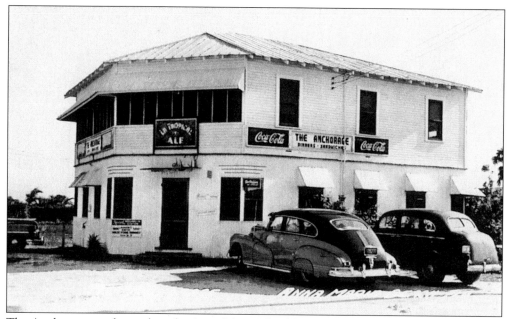

The Anchorage was located on the Anna Maria Island beach, across the street from the original Fast Eddie's. Advertising Coca-cola, Dr. Pepper, and La Tropical Ale, the building also sported a sign announcing that it was the Official Weighing Station for the $5,000 Winter Anglers Fishing Tournament.

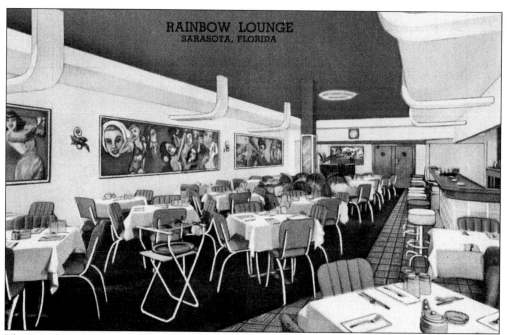

The Rainbow Lounge and Restaurant, on Main Street in Sarasota, had both a cocktail lounge and a dining room. This view of the lounge shows murals of women golfers and bathing beauties. The barfront was composed of multi-colored tiles; the green chairs and yellow walls were typical of the "open, casual look" popular with visitors.

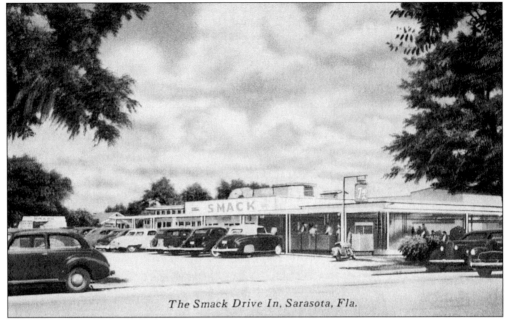

The Smack Drive In, Sarasota, Fla.

At the Smack Drive-In Restaurant, customers honked their horns and carhops dressed in slacks roller-skated to their cars to take their orders. The ticket was slipped under the windshield wiper and a loaded tray was hung on the car door. This spot, on Main Street in Sarasota, later became a citrus shop for Midway Groves.

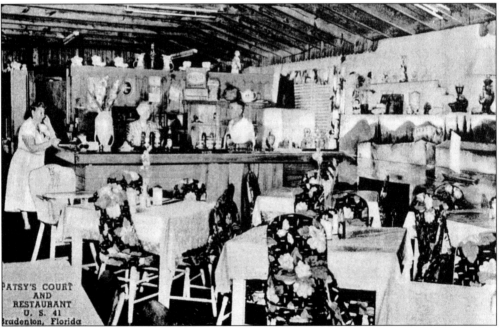

Patsy's Court and Restaurant combined a place to stay with a place to eat. On U.S. 41 in Bradenton, Patsy's offered daily, weekly, monthly, and seasonal rates at its motel. The restaurant, with its flowered chairs and wall murals, sported knick-knacks on every shelf. Delicious American, Italian, and Hungarian foods were prepared by Patsy herself.

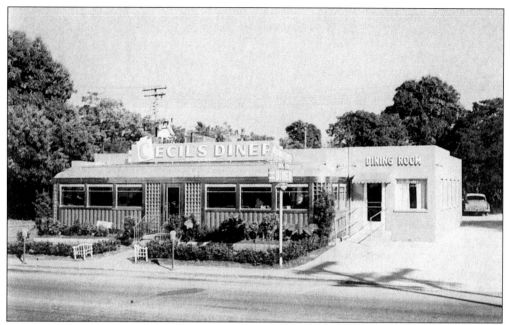

Cecil's Diner, on U.S. 301 in Bradenton, kept customers cool with its air conditioning. The dining room could be reached either by the steps at the front door or via the ramp, convenient to the parking lot. "Nothing's Finer than Cecil's Diner" was its slogan.

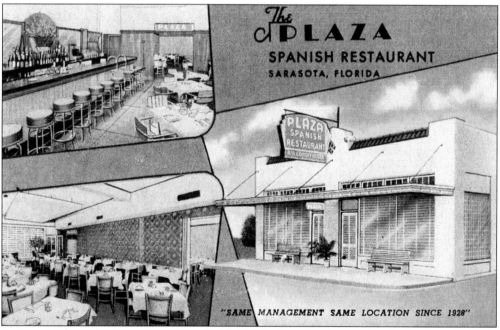

Sarasota's Plaza Restaurant was not a "high-class" place, but its regulars had reserved booths near the front door. Located on First Street it was a favorite hangout for successful young businessmen. On Friday nights, writers and cartoonists would get together there. Spanish food was the Plaza's specialty.

Sarasota's Welcome Center building became Zinn's Restaurant and Cocktail Lounge on the Tamiami Trail between Bradenton and Sarasota. "Noted celebrities from all over the world came here," the postcard proclaims. The restaurant's waterfall and garden views provided a special ambiance. Sadly, Zinn's is no more.

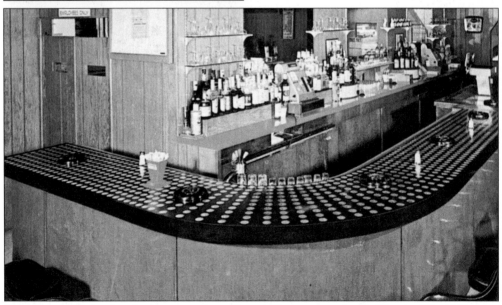

One thousand nine hundred seventy-four silver dollars were embedded in the World Famous Silver Dollar Bar at Herb's Beachview on Bradenton Beach. Its color scheme, including a bright red bar, black stools and bartop, was a popular motif in the 1950s and 1960s. Later, the establishment became Ray's Silver Dollar Bar, and 2,000 silver dollars were touted as being part of the bar. Ray's offered food, dining, and dancing seven days a week.

Six
FESTIVALS AND ATTRACTIONS

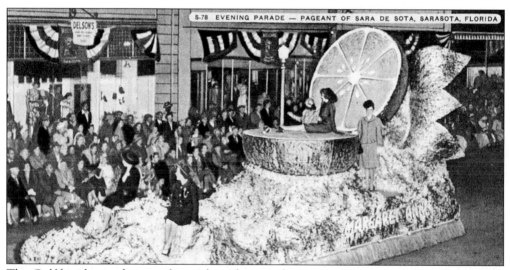

The Gulf beaches and warm climate brought out-of-state visitors to Sarasota-Bradenton. But area festivals and attractions lured Floridians and enticed tourists to stay longer. These special places and events were sources of pride for local residents and created an image of an area with natural beauty, excitement, and fun. The circus became such an integral part of Sarasota that an entire chapter of this book has been devoted to it. Events such as the Sara de Sota pageant and the week-long festival commemorating Hernando de Soto's exploits, as well as sites such as Braden Castle and the Gamble Mansion created a sense of history. Sarasota Jungle Gardens, Floridaland, and Sunshine Springs focused on the tropical beauty of these Florida towns. Horn's/Bellm's Cars and Music of Yesteryear, the Circus Hall of Fame, the Ringling Estates and Museums, and other area sights became favorites of locals and tourists alike. This float in the Pageant of Sara de Sota evening parade celebrated the citrus industry as the big orange passed in front of Delson's.

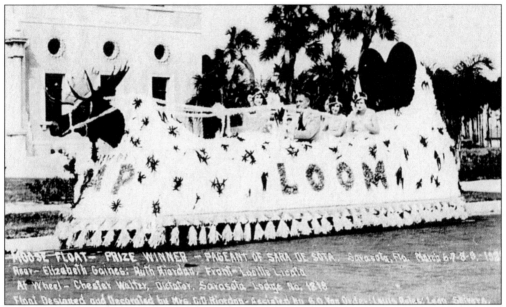

This Moose Float was a prize-winner at the Pageant of Sara de Sota, held March 6 through March 9 in 1929. At the wheel is Chester Walter, dictator, Sarasota Lodge No. 1319. The first pageant was held in 1916, and thousands of visitors came to the five-day event. Buildings were decorated, and events included carnival rides, aquatic shows, field races, and fireworks.

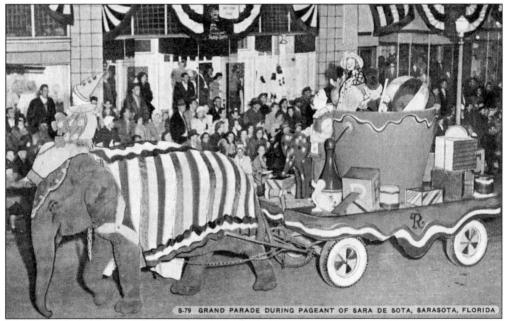

Having the Ringling Brothers, Barnum & Bailey Circus's winter quarters in Sarasota added elephants and clowns to the parade and pageant events. Festival promoters explained, "Many years ago Sarasota's pioneer settlers realized that at least once each year those so unfortunate as not to live here should be invited to view the cities' charms in a quaint manner. It is an annual celebration when citizens and visitors alike don Spanish costumes and mingle in festive atmosphere."

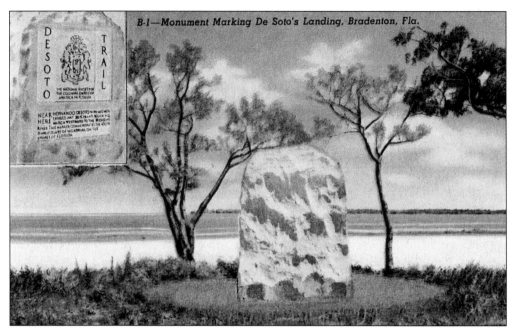

B-1—Monument Marking De Soto's Landing, Bradenton, Fla.

In 1939, the Society of Colonial Dames of America dedicated this 8-ton granite memorial at what was Shaw's Point, 4 miles west of Bradenton on the bank of the Manatee River. The de Soto National Monument marks the landing place of Hernando de Soto and his 800-man expedition on May 30, 1539. The expedition camped here for two months and then began a three-year overland march to explore the interior of the southeastern United States.

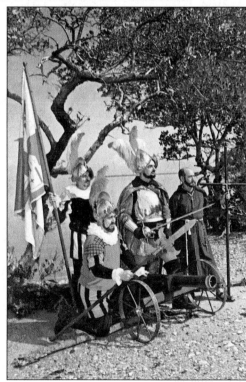

Every March, de Soto's historic exploits are portrayed in a week-long festival. Authentically costumed "conquistadors" re-enact the landing of the expeditionary force. The site is maintained by the U.S. Park Service and is designated a National Park.

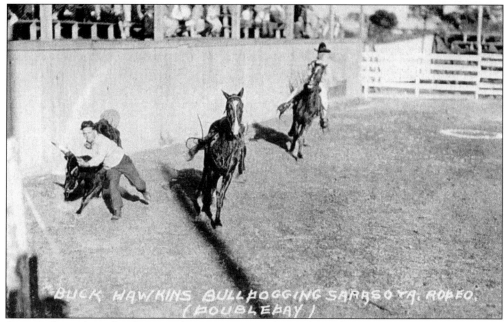

Sarasota hosted a rodeo for several years. Here, Buck Hawkins is shown "bulldogging."

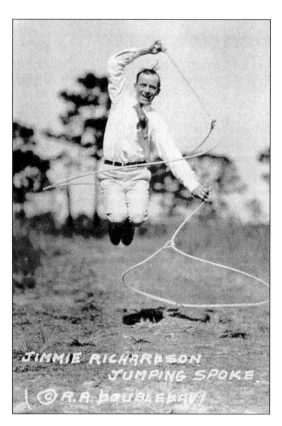

Jimmie Richardson was known for his incredible rope tricks. Here he is shown twirling two ropes, one circling his body as he leaps into the air. He performed at the Sarasota rodeo.

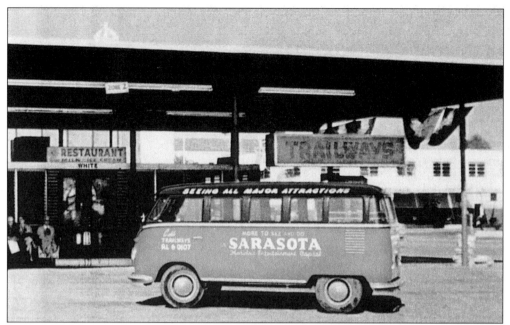

Trailways began running a Sarasota City Sightseeing tour, which departed from the Trailways Bus Terminal at Ringling Boulevard and East Avenue. The daily excursions in their distinctive vans boasted, "Every trip is a lectured tour."

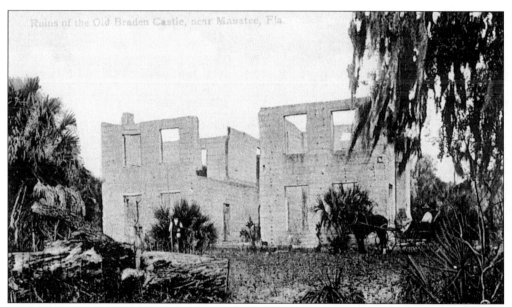

A popular tourist destination was Braden Castle. Built with slave labor in the 1840s, it was destroyed during the Civil War. With walls 20 inches thick, the building was a refuge for local residents during the Seminole uprising. Dr. Joe Braden's home was the most pretentious in Manatee.

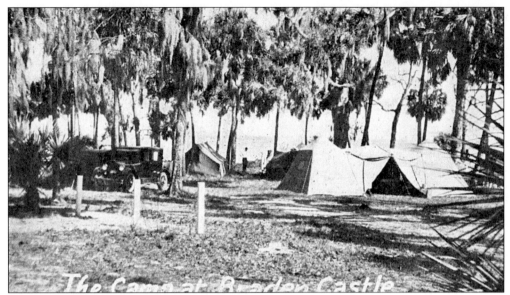

By the early 1900s, nothing remained of the castle but a few sections of wall. After it was abandoned, the site became a favorite place for picnics. In 1924, the Braden Castle Park Historic District was laid out. The small frame cottages, trailer sites, and large communal buildings were designed to serve as a seasonal campground for the Camping Tourists of America.

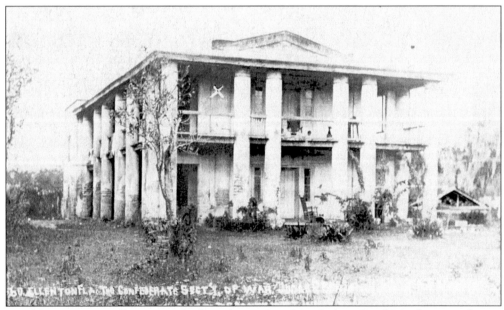

Gamble Mansion in Ellenton was built in the 1840s as Maj. Robert Gamble's plantation home. The "X" marks the hiding place of Confederate Secretary of State Judah P. Benjamin during the Civil War. After five months, Benjamin escaped, making his way to London where he began a career as a barrister. In 1925, the mansion was saved by the United Daughters of the Confederacy. It is the only antebellum plantation house left in southern Florida.

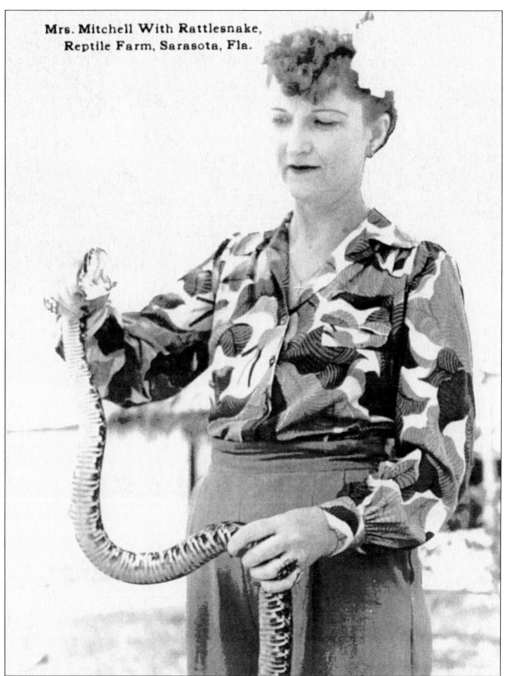

Mrs. Mitchell With Rattlesnake, Reptile Farm, Sarasota, Fla.

Small individual and family-run attractions vied for the tourists' dollars and admiration. The Reptile Farm in Sarasota displayed an array of native alligators and snakes. Here, Mrs. Mitchell holds a rattlesnake, carefully gripping it behind its head. The snake's jaws are open, adding a sense of danger to the thrill of the event. In the early days of automobile travel, roadside amusement areas provided a good opportunity to stretch tired legs, have a bite to eat, and see unusual sights. Today, large corporations own most amusement parks, and the "Mom and Pop" tourist spots have dwindled.

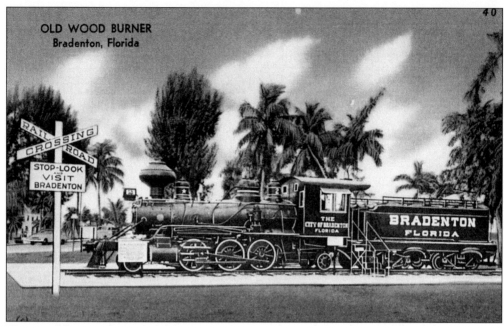

This wood-burning locomotive, known as Old Number 2, was established as a tourist site by the City of Bradenton. It is reminiscent of the days of slow-moving trains. Children could climb up into the locomotive, and historical information about trains was provided.

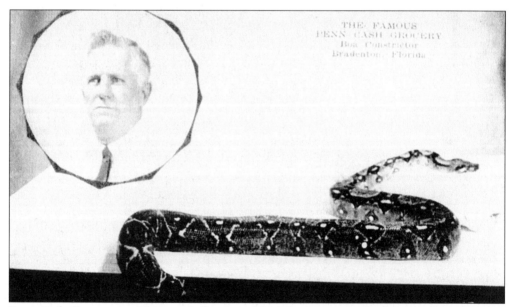

Penn Cash Grocery, on Thirteenth Street and Eighth Avenue in Bradenton, invited visitors into the store to see this boa constrictor. The snake was 16 inches long when it was found hidden in a bunch of bananas imported from South America, in 1919, by a store employee. The snake grew to be 10 feet, 4 inches long.

This pre-1907 postcard shows what is purported to be the largest cactus plant in Florida, located in Bradenton. It certainly dwarfs the dapper, bow-tied gentleman standing beside it.

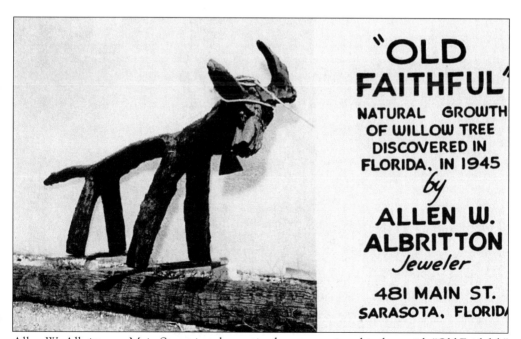

Allen W. Albritton, a Main Street jeweler, enticed customers into his shop with "Old Faithful," a naturally formed wooden "sculpture" discovered in 1945.

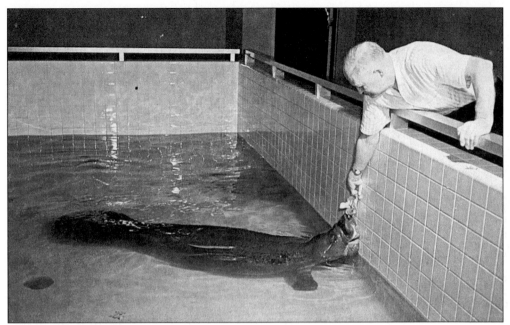

This 1960s postcard shows Baby Snoots, the trained manatee, at the Bishop Space Transit Planetarium in Bradenton. The first manatee born in captivity, Baby Snoots is shown here at the age of 19, having lived its entire life at the museum. Munching on four bushels of lettuce a day, as well as looking at the visitors, kept the manatee busy.

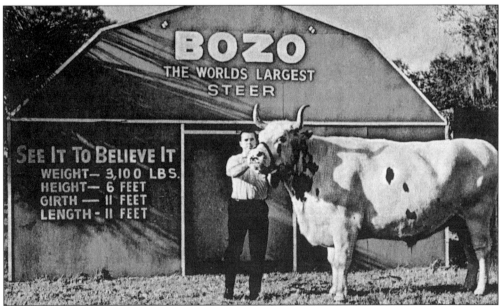

And who could forget Bozo, the world's largest steer? After traveling with circuses and carnivals from his original home in Libertyville, Illinois, Bozo and his human friend settled in Bradenton. The Holstein was seven years old on this postcard, 6 feet tall, 11 feet both in length and girth, and weighed 3,100 pounds. Bozo could eat over a bushel of grain daily.

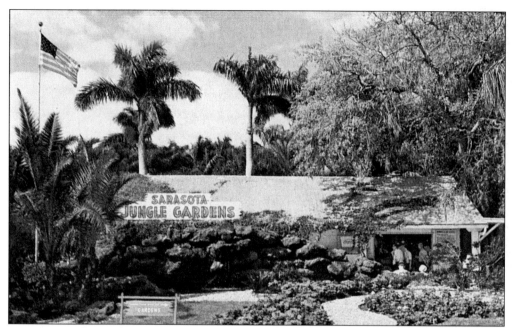

Sarasota Jungle Gardens combined family entertainment with the beauty and restfulness of tropical Florida gardens. Visitors could stroll through areas landscaped with colorful flowers and stroll past quiet, lovely lakes festooned with local birds such as pelicans, peacocks, flamingos, and herons.

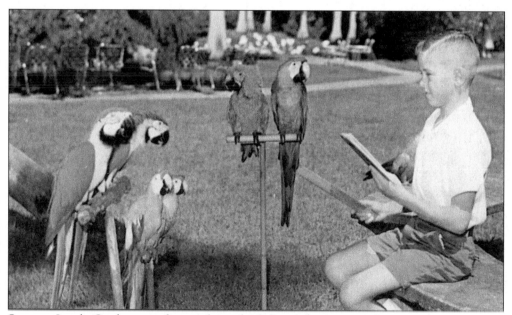

Sarasota Jungle Gardens was famous for its bird shows, featuring performing parrots, macaws, and cockatoos. In the Jungle Bird Circus, our avian friends could be seen riding little bicycles, walking a tightrope, and rolling the barrel to the delight of young and old.

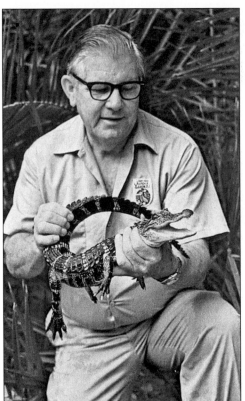

World-famous herpetologist Ross Allen displays a four-year-old alligator. Allen was well known in Florida for his ability to handle and "milk" snakes, and he performed at several attractions around the state. For some time, the Ross Allen Reptile World was located at Sarasota Jungle Gardens.

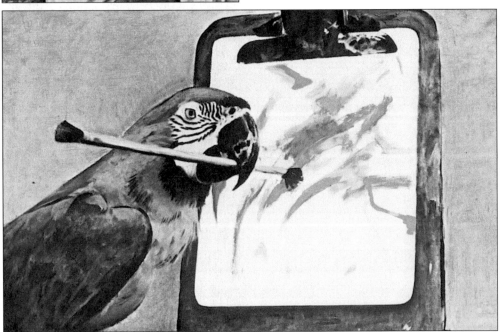

Elvis the macaw was touted as the only bird in the world who could paint. He was the star of Sarasota Jungle Gardens' Bird Circus. Today, the Gardens still attracts visitors and continues to grow. It is still owned by its original founding family.

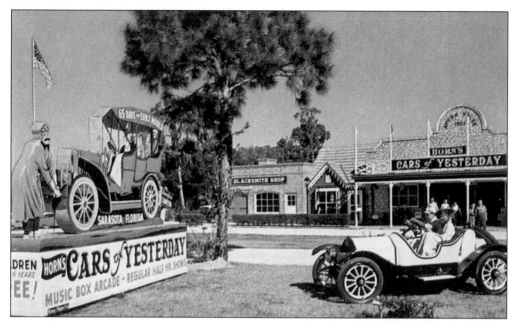

Originally known as Horn's Cars of Yesterday, this attraction is still located on U.S. 41 between Sarasota and Bradenton. Bob and Herb Horn, brothers from Iowa, built the museum in 1953 to house their extensive car collection, among which was a Tucker. As the story goes, Walt Bellm wanted to buy the Tucker, but the Horns wouldn't sell it because it was part of a collection. So Bellm bought the whole collection and the attraction.

Bellm's Cars and Music of Yesterday continues to entertain visitors. In addition to a large display of antique cars, the music museum is one of the few places in the country where calliopes and Victrolas can still be heard. On this early 1960s postcard, the tour guide is surrounded by antique animated music boxes in front of the large Welte Orchestrion called "Nubian Girl."

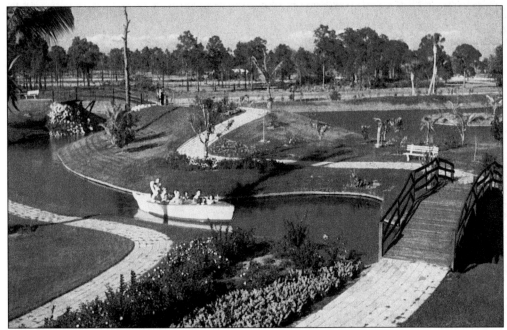

Sunshine Springs and Gardens, a park-like attraction, offered boat rides along picturesque Sarasota waterways. A lovely place for a stroll, the Springs was primarily attended by local people.

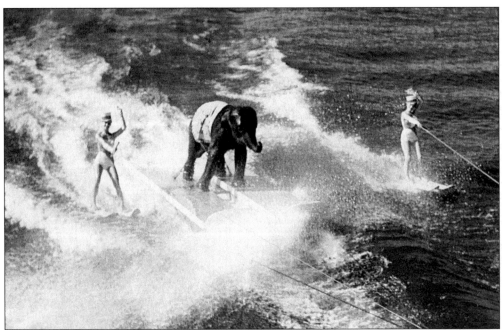

Famous for its water-skiing elephant, the short-lived Sunshine Springs and Gardens was closed in the 1950s. Today, Lakeside Elementary School stands on this site, with the county park next to the school occupying the rest of the old Sunshine Springs land. Some of the original small bridges still remain for park visitors to use.

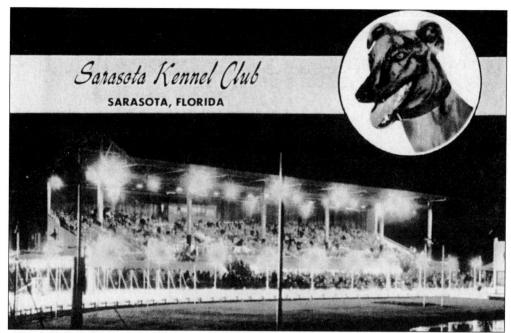

This 1940s postcard of the Sarasota Kennel Club claimed that its racing strip was one of the finest in Florida. The club was a major outdoor sports attraction from the end of February to the first of June. The track was located between Sarasota and Bradenton on De Soto Road between U.S. 41 and U.S. 301.

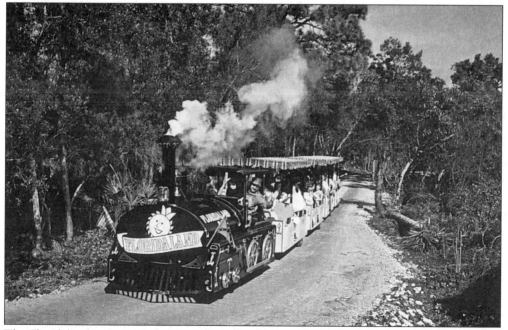

The Floridaland train carried visitors from the front to the back of this large 1960s attraction south of Sarasota. As a promotion, its owners brought in a flying saucer-shaped "House of the Future" that was built for the 1964 New York World's Fair.

Floridaland boasted "ten big attractions at one admission price." They included an Indian Village, porpoise shows, a western town complete with shoot-outs, a cancan girl show, a whiskey still, gardens, jungle trails, a deer park, tour trains, and a ghost town.

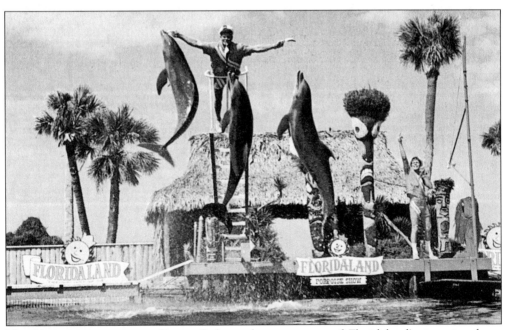

The "fantastic precision triple-jump" shown here was part of Floridaland's porpoise show. Today the leaping porpoises have been replaced by the Southpoint housing development.

Seven
THE CIRCUS STAYS IN TOWN

The big top has become part of our national identity. Where could we dream to go, if not to "run away and join the circus?" Moms and dads vie with grandparents for the privilege of taking the kids to their first circus. The circus truly is, as the Ringling Brothers, Barnum & Bailey announcer coined, for "children of all ages." George Washington attended the first full circus to be held in the new United States, and he swapped horses with its operator. The excitement of wild animals tamed and clowns taking us by surprise with their antics is irresistible to most of us. These things, along with spangled, sparkly costumes, the mingled scents of cotton candy, elephants, and warm summer nights all combine into magical, mystical memories. For most Americans, the circus came to town. But for Sarasotans, the circus stayed in town.

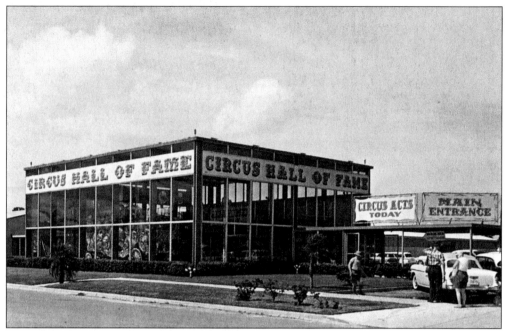

One of the Sarasota's most popular attractions was the privately owned Circus Hall of Fame, just down the street from the Ringling Estates on U.S. 41 North. The building in front served as its museum, shop, and Hall of Fame, where circus greats were enshrined.

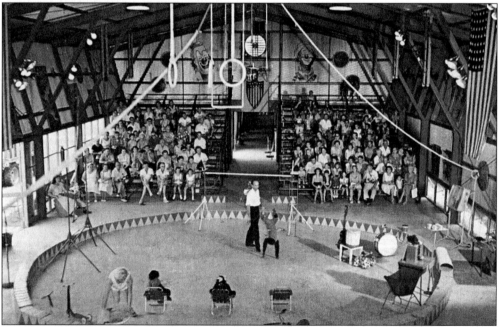

Behind the main building, circus acts and marionette shows were performed daily. Watching the show in this one-ring indoor arena gave audiences an insider's view of the art of circus performance. The experience was like a peek behind the scenes of huge circus tents. Every seat was close up and details that were missed when attending huge circus extravaganzas could be noticed and marveled at in this intimate atmosphere.

The outdoor grounds were often used as a practice area by circus troupes preparing for the next season with their traveling shows. Here, the Royal Hungarian Troupe rehearses. They were internationally known for their Risley Act, shown on the postcard.

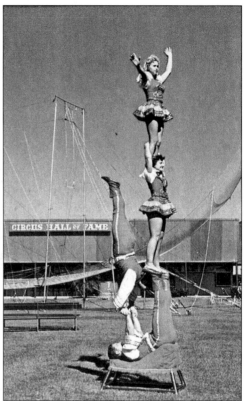

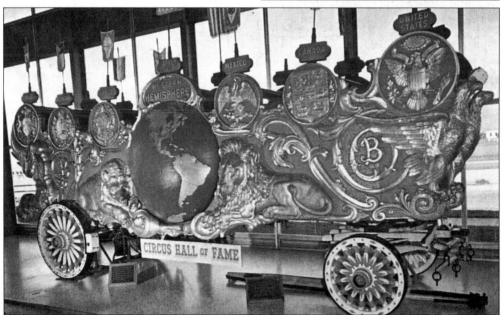

The Two Hemispheres Bandwagon, the largest circus wagon ever built, was on display in the museum. The wagon was featured in every Barnum & Bailey street parade from 1902 to 1918. This view of the Western Hemisphere shows the national seals of Chile, Argentina, Brazil, Mexico, Canada, and the United States.

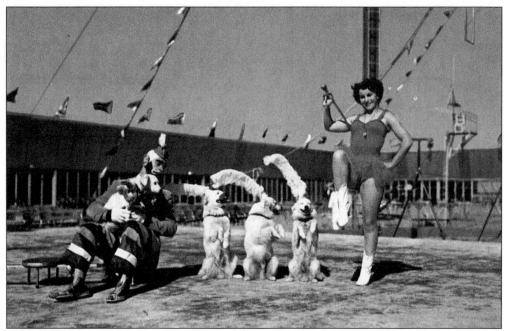

Renee's Canine Cadets perform with a clown in the outdoor arena. Adorned with feathered caps, bandanas, and occasionally skirts, the dogs performed choreographed leaps, did a bit of ballet dancing, and posed majestically.

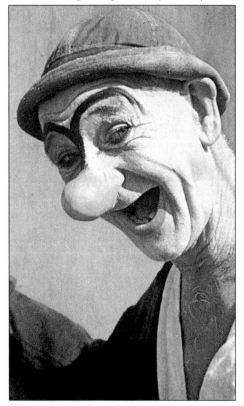

Clowns have always held a special place in the hearts of children and adults alike. Clowns can get away with behavior we only wish we could. Their antics are designed to surprise and entertain. Bumsy Anthony began clowning in 1916 and developed the original "Sad Sack" identity. He is shown here as he appeared at the Circus Hall of Fame.

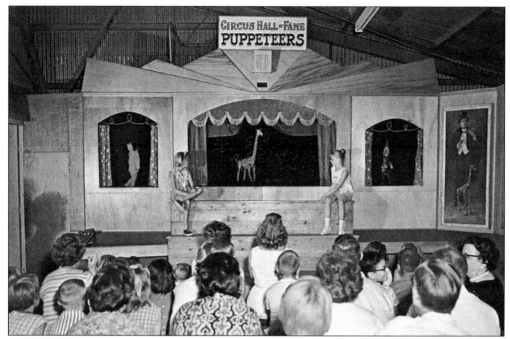

Children had a chance to participate in the marionette shows at the Circus Hall of Fame's Puppet Theatre. Performing shows with circus themes, the marionettes were unique in design. A portrait of P.T. Barnum can be seen along the right-hand wall.

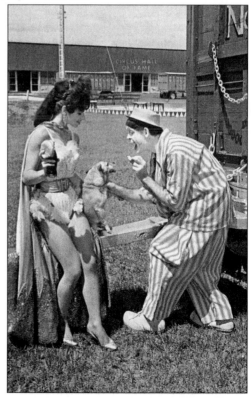

Resting between shows in Clown Alley near the trailer dressing rooms, Carmencita and Bob-O the Clown play with their four-legged friend.

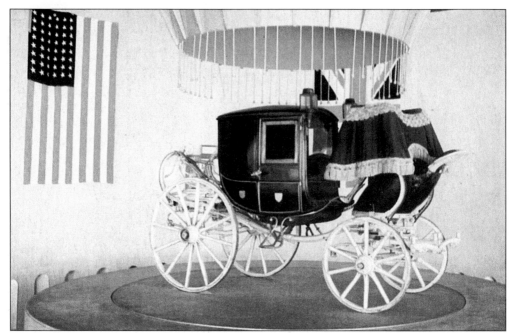

One of the artifacts in the Circus Hall of Fame Museum was the Tom Thumb carriage, given to him in 1854 by Queen Victoria. The carriage was designed for his diminutive dimensions, and he rode in it proudly for years in circus parades. Tom, born Charles Stratton, shared P.T. Barnum's hometown of Bridgeport, Connecticut, and worked with Barnum for decades.

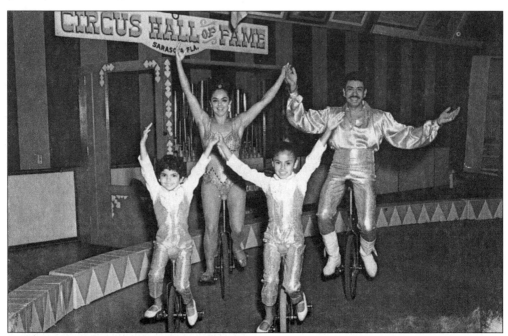

The Navarro Family, "cyclists supreme," often performed in the indoor arena. Family acts such as this, sometimes encompassing three or even four generations, were especially thrilling to children, who could dream of being the little ones in the circus ring.

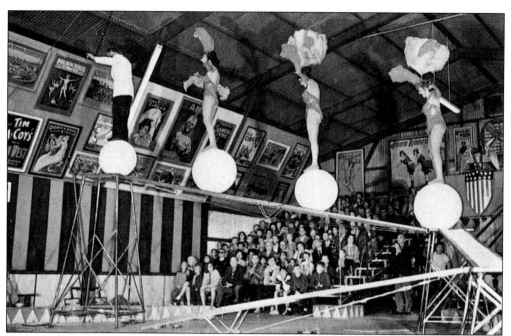

The Lacey Troupe performed its spectacular rolling globe act in the Circus Hall of Fame's indoor arena. Making their way up and down ramps walking on large balls, the Laceys' heads almost brushed the ceiling of the arena. The arena walls were decorated with posters from many different circuses.

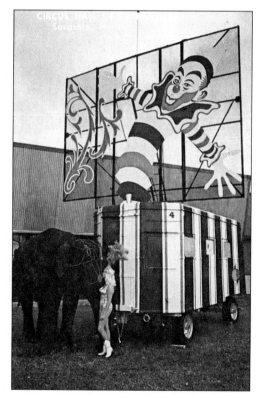

The Circus Hall of Fame was well known for its collection of historic circus wagons. This was the last of the Ringling-Barnum ticket wagons. It was used when The Greatest Show on Earth played under the big top.

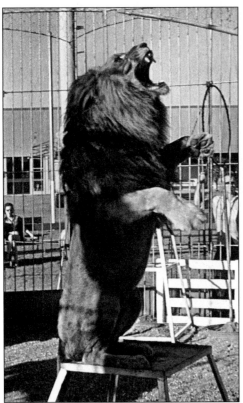

No circus is complete without performances by wild animals. Lion taming was traditionally a family occupation, with one generation training the next. Because Sarasota was the winter home of several circuses, there were many circus families who lived in the area off season, and many who settled there permanently.

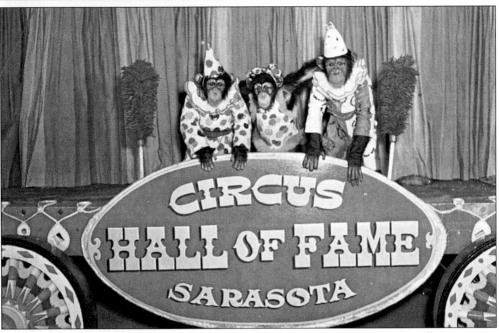

The Circus Hall of Fame is no longer. Many of the items in its museum collection were transferred to the Ringling Museums in Sarasota and Baraboo, Wisconsin. The performers in its Hall of Fame live on in the hearts of circus audiences everywhere.

When five of the seven young Ringling Brothers from Baraboo, Wisconsin, began a traveling circus in 1883, Sarasotans had no idea how much this would impact their community. In the circus's official route book, John Ringling was listed as proprietor, manager, router, and railroad contractor.

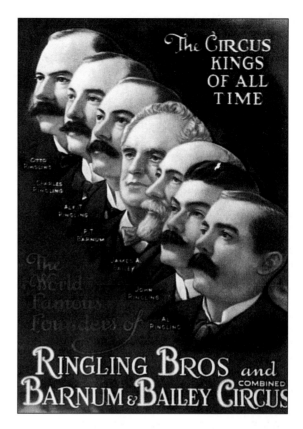

Ringling is the Americanized version of the German name Rungeling, and these brothers were to become the most famous circus owners in the world. In 1890 the extravaganza became known as the Ringling Brothers Railroad Shows. In 1911, John and his brother Charles bought property on Shell Beach in order to winter there.

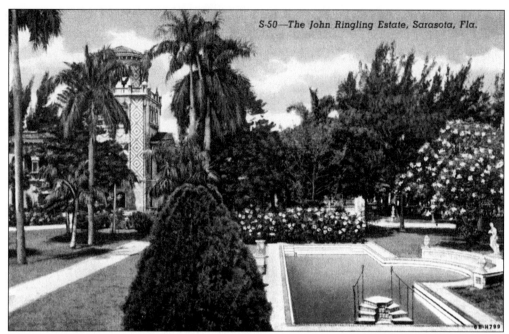

The John Ringling Mansion, on the shore of Sarasota Bay, still sits on 30 acres of the 66-acre estate. Winding paths through lush gardens are lined with statues and tropical plants. The estate adjoins the John and Mable Ringling Museum of Art and is open to visitors.

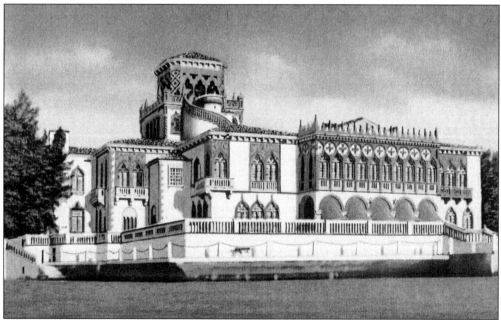

The mansion, called Ca' D' Zan (meaning "House of John"), is four stories high and has an elevator, marble bathrooms, and stained-glass windows. Designed by noted architect Dwight Baum, Ca' D' Zan took two years to build at a cost of $3 million. When the movie *Great Expectations* was filmed at the house in the early 1990s, a fake entranceway was built; the house was painted to look shabby and dead plants were strewn all around.

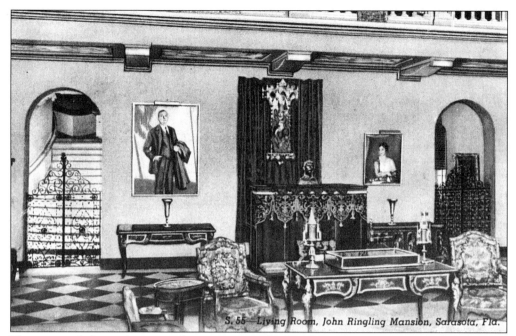

S. 55—Living Room, John Ringling Mansion, Sarasota, Fla.

This postcard shows the ornate living room in the Ringling Mansion. Framing the organ are well-known portraits of John and Mable Ringling. Statesmen, diplomats, and leaders in both the artistic and professional worlds were entertained by the Ringlings in this gated room.

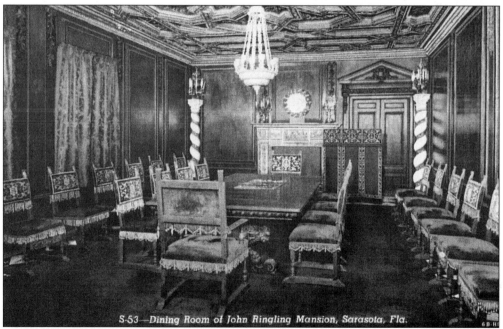

S-53—Dining Room of John Ringling Mansion, Sarasota, Fla.

Built and furnished in Spanish style, Ca' D' Zan's heavy red drapes and chair cushions added to the formality of the dining room. Normally set to seat ten, the dining table could be enlarged to seat several more people. Elsewhere in the house, John Ringling had his own private barber's chair.

115

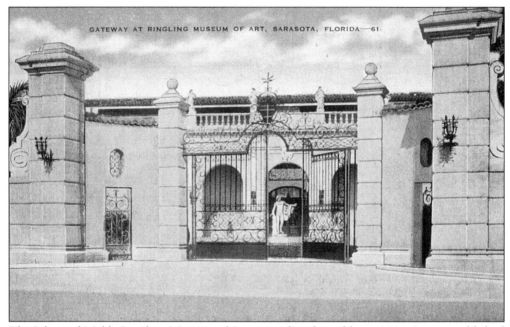

The John and Mable Ringling Museum of Art opened to the public in 1931. It was established by John as a memorial to his first wife. The building alone cost $2 million, quite a tidy sum in those days. The tall iron gates at the entry still swing open at ten each morning to admit visitors.

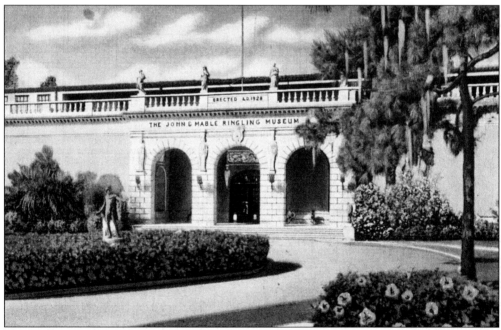

The museum was built in the Italian Renaissance style, and it still houses a collection of 17th-century Italian paintings as well as an extensive collection of the works of Peter Paul Rubens. Its cloistered porch had 81 marble columns from Greece, which were over 1,000 years old.

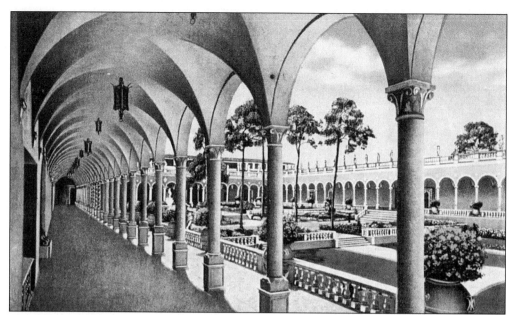

The John and Mable Ringling Museum of Art was built around a courtyard that measured 150 by 350 feet. There were literally hundreds of antique marble statues, arches, and doorways in the museum when it first opened. The top balustrade alone had 76 life-size statues.

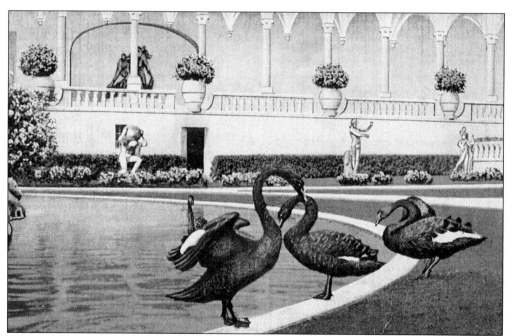

In the courtyard that surrounded the cloistered porch of the John and Mable Ringling Museum of Art was a bronze reproduction of Michelangelo's *David* and a pool. Rare black swans added grace and charm to this inner court.

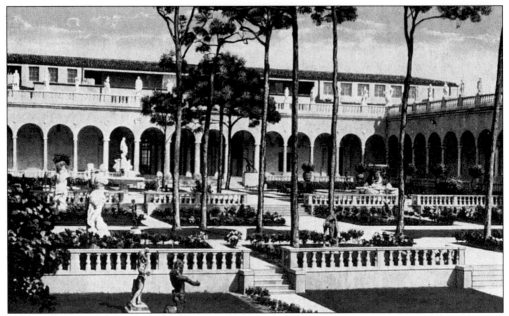

The Ringling Art Museum housed the largest collection of original paintings in the world. Along with its other art pieces and sculpture, the works on display were valued at $28 million. A school of art and a junior college were associated with the museum.

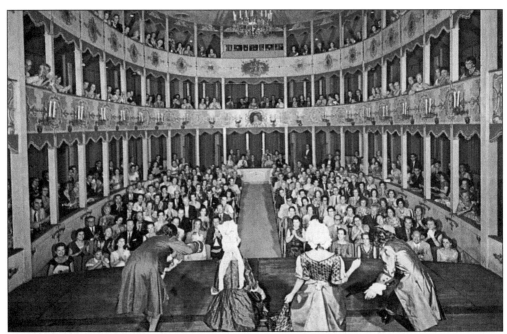

The Asolo Theatre, America's only 18th-century European theatre, still stands on the grounds of the Ringling Museum of Art. It has long been the permanent home of the Florida State Theatre Company. This scene is from a restoration play during the professional company's February-to-September season.

The Ringling Museum of the Circus was also constructed on the grounds of the John and Mable Ringling Museum of Art. It was one of the Florida State-owned Ringling museums and still houses a vast collection of circus memorabilia.

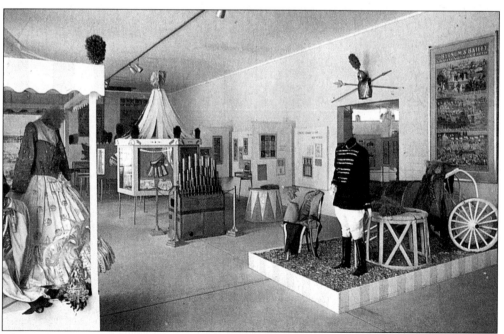

This early 1960s view of the Circus Museum's interior shows authentic costumes, colorful lithographs, and circus equipment. The museum's inner rooms house displays, which trace the history of the circus in general and of the Ringling Brothers, Barnum & Bailey circus in particular.

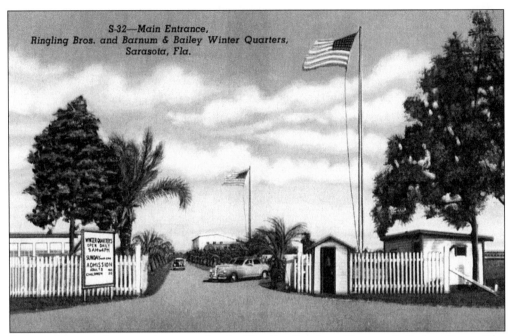

Sarasota became the winter quarters for the Ringling Brothers, Barnum & Bailey Circus. The circus grounds opened to the public on Christmas Day in 1927 to huge crowds. Sarasota became known as the "Circus City," and the winter quarters became a tourist attraction second to none in the state. The boost to construction and tourism helped pull the city out of the depression.

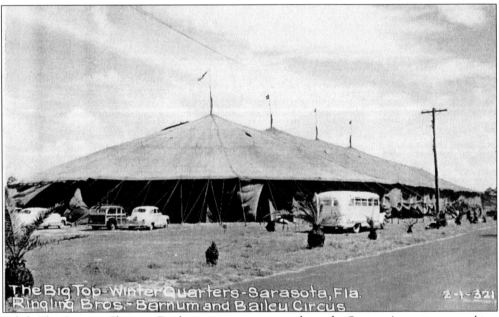

While The Greatest Show on Earth spent its winter months under Sarasota's warm, sunny skies, equipment was repaired, animals rested, and plans were made for the coming season. On Sunday afternoons there was a two-hour show. The weekly performance, in an open-air arena, was the place where new acts were tried out and old acts were polished.

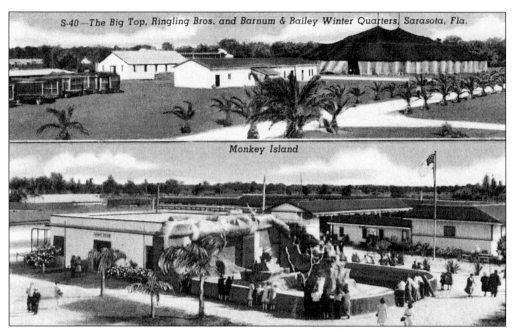

Resting on 200 acres, the winter quarters was a year-round attraction with an admission charge of 90¢ (kids got in for 50¢). The grounds included a Big Top and many buildings that housed the large and varied menagerie.

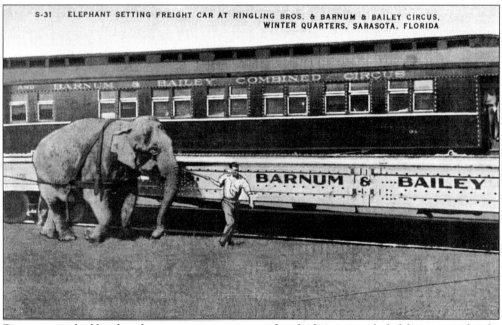

Everyone worked hard at the winter quarters; even the elephants were helpful in setting freight cars. Visitors could see a museum of floats and get a behind-the-scenes peek at circus life, watching performers and animals prepare for the following season on the road.

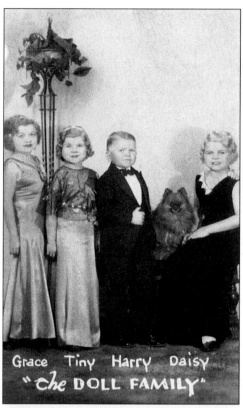

The Doll Family, born the Schneiders and also known as the Earles, ranged in height from 3 feet 1 1/2 inches to 3 feet 4 inches. Originally from Germany, they spent many years with the Ringling Brothers, traveling from April to November and spending the rest of the year in Sarasota. Tiny was the smallest, Harry was the sportsman, Grace was the oldest, and Daisy (billed as the miniature Mae West) was the tallest.

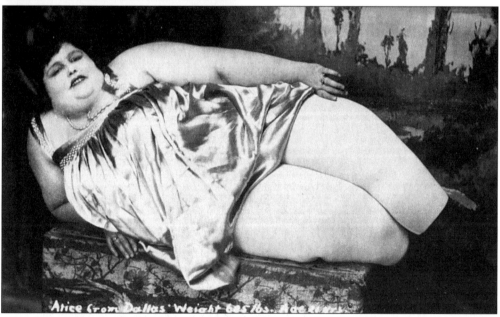

Alice from Dallas, born Alice Dunbar and also known as Alice Wade, actually did come from Dallas, Texas. After traveling with The Greatest Show on Earth for several seasons, wintering in Sarasota, she finally retired to her home town. In this postcard, Alice was 21 years old and weighed 685 pounds.

Burlesque girls, like Anna Toebe of the Minstrel Maids, were always a popular circus attraction. This costume, thought to be quite revealing in the early 1900s, would not be considered very risque today.

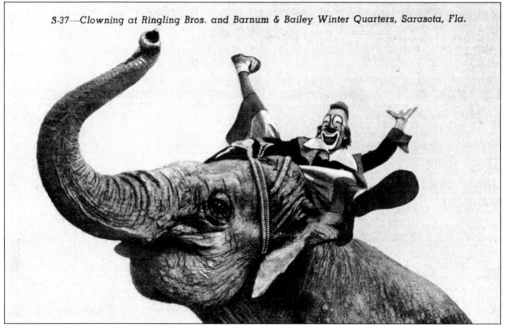

S-37—Clowning at Ringling Bros. and Barnum & Bailey Winter Quarters, Sarasota, Fla.

There is something about a white-faced clown that appeals to everybody, young and old. Even the elephant seems to be having a good time! Always, but especially during the depression years, the circus coming to town meant forgetting cares and woes and stepping into the exciting and happy world under the big top.

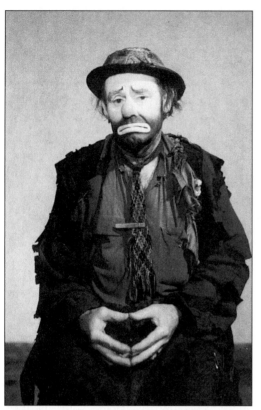

When Sarasota was still a small town, circus greats could be encountered on any street corner. The Flying Wallendas, the trick-riding Cristianis, the acrobatic Brothers Ivanov, and the bicycle whiz Honey Schiretto spent much time in Sarasota. Emmett Kelly as Weary Willie, a world-famous clown, was photographed at the winter quarters. Today, many of the old stars still live in an area stretching from Venice to Tampa.

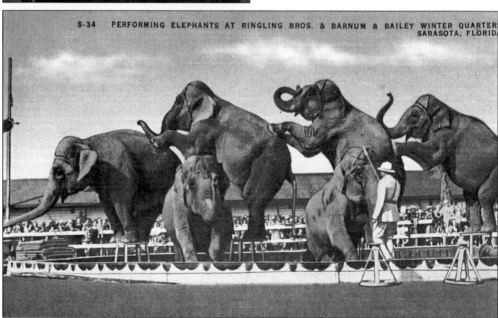

Here, an elephant trainer puts the huge pachyderms through their paces at their winter home. Sarasota sprouted circus suburbs like Deland (home of the Beatty-Cole Show), Venice (where Ringling's winter quarters moved in 1961), and Gibsonton, inhabited largely by circus and carnival people.

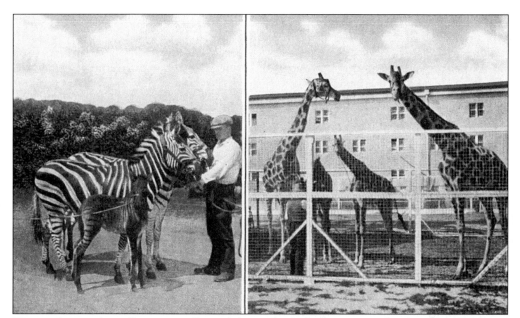

These zebras and giraffes were well cared for at the winter quarters. This late 1920s postcard notes that circus animals and props helped "make the Pageant of Sara de Sota in February one of the largest and most spectacular events of its kind in the world."

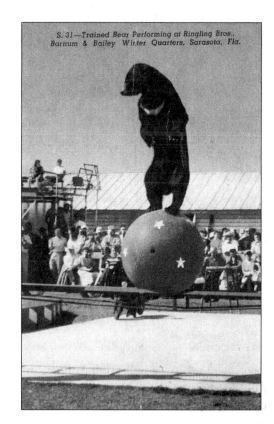

Ringling Brothers always held themselves to a high ethical standard when operating their circuses. Five of the seven Ringling brothers, Otto, Charles, John, Al, and Alf T., owned the show, and the other two worked for the circus. New high-quality acts, such as this trained bear, were sought year after year.

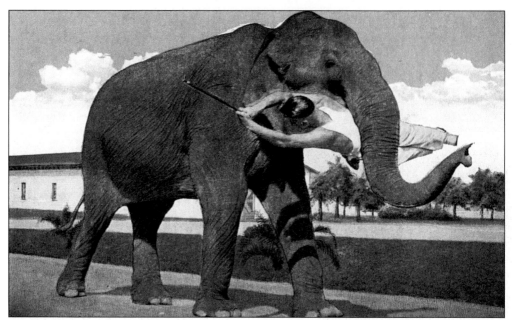

While this late 1920s postcard claims to show a performing elephant, it seems as though the trainer is performing just as diligently. Being carried in an elephant's mouth can't be the most comfortable way to get from place to place.

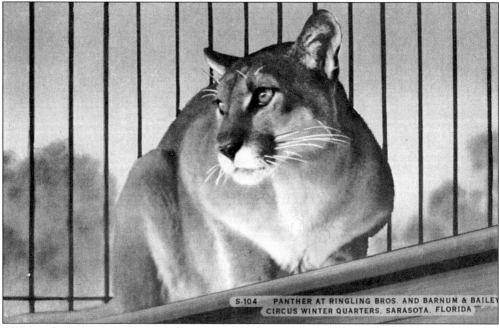

This panther is sitting on its perch, just waiting for its cue to perform. By the 1950s, visitors to Sarasota could see the winter quarters of three different circuses, the Florida-owned Museum of the American Circus, and the Circus Hall of Fame. Around town they would see many homes of circus people with performers practicing on rigging in their back yards.

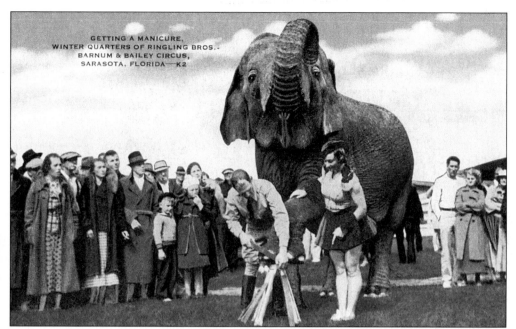

The entire herd of elephants traveling with the circus was put through a regular routine of daily training and grooming to prepare for the next season on the road. Grooming included manicures to keep their toes painted white, which this elephant seemed to enjoy.

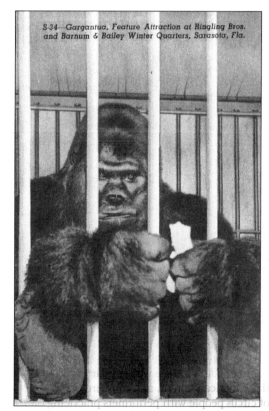

John Ringling died in 1936 and his nephews, John Ringling North, son of the brothers' little sister, and Henry Ringling North, took control. John had been in and out of favor with his uncle because of his playboy ways. He favored showgirl acts and sensationalism such as the gorilla Gargantua, a feature attraction.

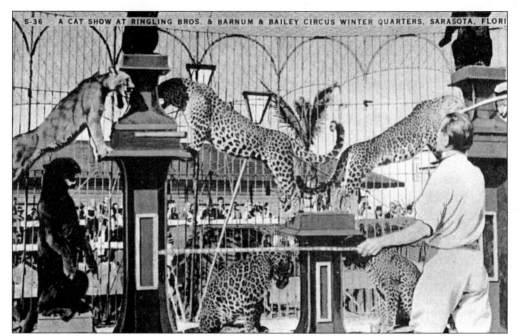

The winter quarters property was on the corner of Fruitville Road and Beneva. Many local residents happily recall "working" for the circus as children. When they carried buckets of water to and from the elephants, they earned free admission to the circus. Some of the long, narrow buildings still remain and have been made into homes for circus people.

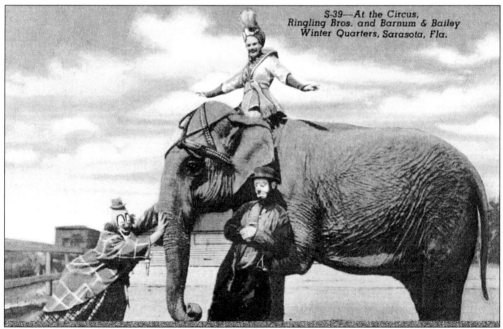

The year 1956 was the last year that a full-size big top was set up on the Ringling lot. It was also the last year that the entire circus personnel moved by rail. The circus moved its winter quarters to Venice, Florida, in 1961 after a disagreement with the city of Sarasota over taxes.